THE CREATIVE CARTOONIST

Other Books by Dick Gautier

The Art of Caricature

THE CREATIVE CARTOONIST

DICK GAUTIER

A PERIGEE BOOK

Perigee Books
are published by
The Putnam Publishing Group
200 Madison Avenue
New York, NY 10016

Library of Congress Cataloging-in-Publication Data

Gautier, Dick.
The creative cartoonist.

1. Cartooning—Technique. I. Title.
NC1320.G38 1989 741.5 88-12590
ISBN 0-399-51434-1

Printed in the United States of America
7 8 9 10

CONTENTS

INTRODUCTION

I can't remember not drawing. If there had been a pencil handy when I was born I'm sure I would've turned out a quick sketch of the doctor and perhaps a rendering of the interior of my mother's womb. I am, and have always been, a compulsive doodler who now wishes he had that proverbial nickel for every sketchbook he's filled.

Cartooning has been my hobby, my therapy, a delicious pastime, and, on occasion, my salvation (it got me through some tight financial spots when I was a struggling actor)—which brings me to this: why an actor would have the presumption to write and illustrate a book about cartooning. Perhaps the success of my first book, *The Art of Caricature*, so overwhelmed me that I was easily talked into another book. Also, I'm a sucker for doing something I love as much as drawing—and getting paid for it to boot. I hope this book will communicate to you my unbounded enthusiasm and inspire everyone—those of you who don't draw, those who do but have lost interest, and those who want to draw but are afraid to try.

In the past I have motivated a few of my friends into taking up pen and/ or brush. This was accomplished either by setting an example—they saw a painting of mine and muttered something semi-rude like "Well, if *he* can do that I certainly can"—or by relentlessly badgering them and convincing them that with art the joy is truly in the journey. The final product can in no way compare with the excitement of creating it. Art, whether it's bizarre abstractions, underwear designs, pornographic needlepoint, or just plain old cartooning, is food for the soul. Without art in our lives we are truly undernourished. I sincerely hope that this book will furnish you with a good hearty meal or at the least a tasty snack.

CREATIVE CARTOONIST

What is cartooning, anyway? It's a hobby, a time killer, a profession, a weapon, but, as far as I'm concerned, always a pleasure and a joy. Not everyone holds cartooning in high regard; in fact, many feel the opposite is true: many see it as a demi-art at best, ''advanced doodling,'' even a childish waste of time. But since the cartoon dominates the worlds of advertising, magazine, children's book, and greeting-card illustration, and of course animation, there is no doubt that this deceptively simple art will be with us as long as there is laughter. Maybe it *is* the child in us who responds to these simple little humorous sketches, but then what's wrong with that? Few of us can flip through a magazine without pausing to read the caption below a cartoon. Cartooning has become a cultural pop phenomenon, a mainstay that we look forward to as much as baseball or the movies. Another example of this art's popularity: when several major newspapers once attempted to delete their daily comics in a burst of misguided economic fervor, the decision was met by such an onslaught of letters from the indignant readership that the comics were reinstated posthaste.

Why is cartooning so appealing? Why have we embraced these silly little pictures? Besides the obviously humorous aspect, we are drawn to the simple uncluttered line, the direct frontal attack inherent in every good cartoon, whether it be a quick pen-and-ink sketch or an elaborate, painstakingly airbrushed piece of work. This simple reason for being acts at once as a strength and a weakness. The word *cartoon,* which originally referred to a preliminary drawing for a tapestry or mural painting, has come to mean any extremely basic, often humorous drawing, most commonly distributed through the medium of the press. But as is the case with silent-film makers, whose art was honed and

refined by the absence of sound, or black-and-white photographers like Ansel Adams, who deliberately eschewed color in order to convey a unique view of the world, the simple techniques of cartoonists have become a positive force through their strange and wonderful commentary on the human condition.

More often than not today's cartoonist tends to amplify an event, a trend, or a personality with broad humor. The cartoon is instantaneous exposition and recognition. Its symbols are rarely vague; they are there to be read immediately—no gray areas here. The very nature of cartoons defies pondering. When readers approach a cartoon they are seeking a quick humor fix. The last thing they want to do is dally over a drawing in order to ascertain some oblique or hidden meaning. The skillful cartoonist is a master of brevity, someone who can, in a few deft strokes, create an image that will cause laughter, discomfort, or even pain.

Cartoonists need not always be superior draftsmen; a unique slant, line, or style are all viable substitutes for pure talent with a pen. Naturally you should try to become as skilled as possible if you want to open up other avenues of expression and income. Cartoonists with limited abilities unintentionally remove themselves from the lucrative areas of children's books, magazine illustration, greeting cards, poster and package design, the editorial page, and book jacket art, for example. But still, if I had to name the most important asset for a cartoonist, I would say a highly developed, unique sense of humor. There are several very successful artists whose art is less than perfect but whose deliciously jaundiced view of the world more than makes up for their lack of traditional artistic skills. Cartoonists view the world through their own distorted fun-house mirror, a special set of lenses that allows them to magnify and bring to light the smaller inconsistencies, injustices, and inequities of everyday life or even broader, more ambitious targets such as politics, cultural upheavals, or racial intolerance—the attack is the same, only the targets change.

Furthermore, sketching and doodling are decidedly therapeutic activities. Edward Hill, in *The Language of Drawing,* said that ''drawing is an act of meditation.'' It's a way of crystallizing our thoughts, of placing in perspective the things we so often take for granted. Drawing is considered by many to be the purest manifestation of thought in that it is unencumbered by words, structure, syntax, and so on. You merely think it and it flows through your hand onto the paper, the most direct route from brain to expression. In this book I'll outline the basics, the tricks, the techniques, and the shortcuts . . . all in the hopes of inspiring you, intriguing you, or just plain hooking you on the joy of drawing cartoons.

People frequently offer me the well-worn cliché ''I can't draw a straight line.'' Well, who can? That's why ruler companies are still in business. Drawing straight lines is not art. Art is a deeply personal view put forth in visual terms that other people can understand, or sometimes just feel.

But cartooning must be totally and quickly understood to qualify.

Although I don't like to use *don'ts* (it smacks of parental finger-wagging), I will indulge in one or two in this book. The first and most important is: *Don't* be intimidated by art. That reaction produces nothing. And there is really nothing to fear. One great thing about art is that we never have to show anything to anyone unless we so choose (and then if we hear things we don't want to hear, so be it). In art there is no failure, merely growth, to change, to experiment, to try the new and different. So-called failure, then, is just a step along the way. If you will view your work from that perspective you'll be less demanding and hard on yourself and consequently more productive.

Remember that no one is born a wonderful painter. We've heard about the prodigies who composed and played sophisticated music when they were barely able to reach the piano keys, but a child who paints a masterpiece at age seven . . . I haven't heard about one yet.

When you sit down to draw, clear your mind of preconceived ideas; applying external standards to something that hasn't yet been born is a hindrance. Allow your work to evolve naturally, easily. Like the beginning tennis player who awkwardly flails the ball and stumbles about the court until he can finally return the ball with some grace and consistency, you will see your talent evolve. Join the club, flail, and stumble away. We all do.

The first step is to get in the habit of sketching, doodling, playing with pen and paper. This is going to be a long and close relationship, your hand and pen and paper, so you may as well start cultivating it right now. Take a sketchbook and pencil wherever you go and begin to draw anything and everything. Develop the hand-eye coordination that is so essential to the artistic process. Do it and keep doing it until you are no longer wary of that blank sheet of paper. There's a phenomenon worth mentioning—the blank-canvas syndrome. Some people, artists and amateurs alike, quake and perspire at the sight of a blank canvas or sheet of paper. I feel just the opposite. The Japanese have a word in their language that means two things, "crisis" and "opportunity." Though it may feel like a crisis, the blank sheet of paper is a wonderful opportunity. You can fill it with your ideas, your visions, your dreams. Your own distinct personality can shape the art that will flow onto that page. It's an adventure, so try to see it in that way.

Of course, like any other art, cartooning subscribes to specific criteria. It has boundaries and rules, but it's comforting to know the ground rules. Structure is not an inhibiting agent but a necessity and an aid. Once you have mastered or at least feel comfortable with a few basic concepts, we can move on to more sophisticated forms of this enormously enjoyable art.

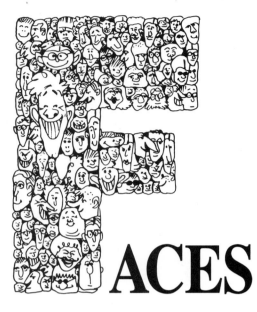ACES

Let me lay out a basic grid of the human head according to ''normal''
and then cartoon specifications. In the normal head the eyes are placed
midway between the top of the head and the chin. A line down the center
of the face intersects the line of the eyes.

But in a cartoon the nose or even the mouth can be placed on the center
dividing line. You have much more freedom and room for experimentation.
For instance . . .

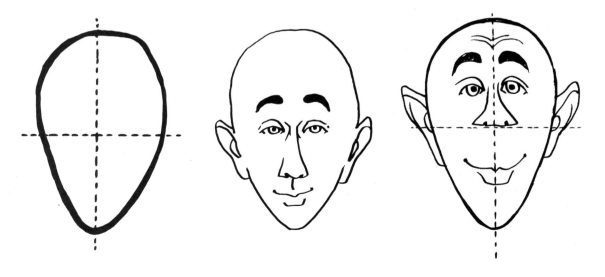

Besides the oval, head shapes fall into a few other basic geometric categories.

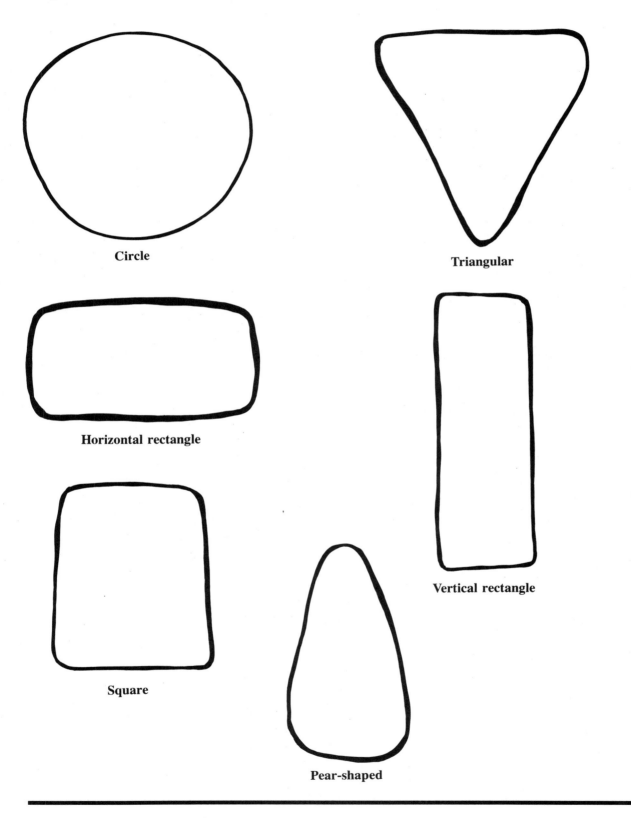

Circle

Triangular

Horizontal rectangle

Vertical rectangle

Square

Pear-shaped

Now, as I place the same facial features inside various shapes, notice
how radically the character of the face changes.

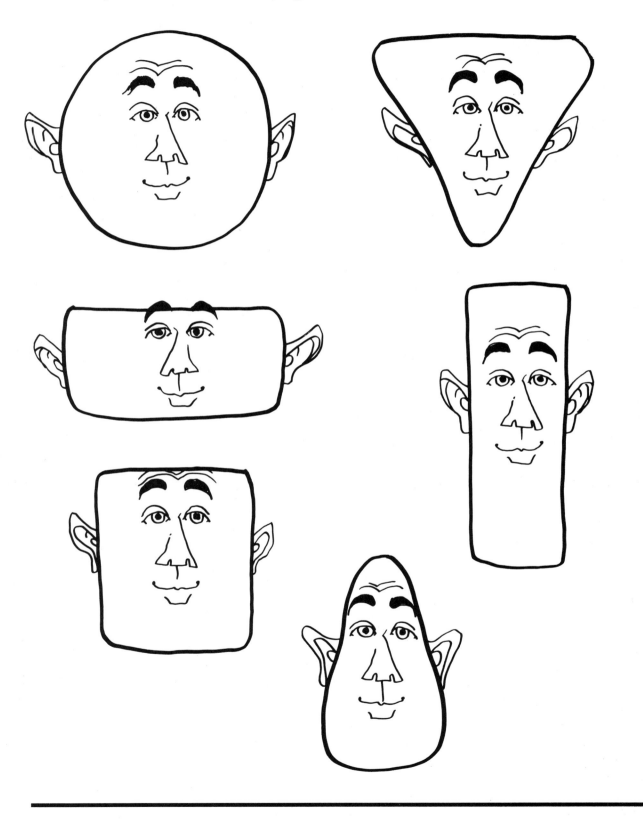

Now let's turn that head to a three-quarter view and a profile. Notice that the features remain in the same position, much like lines on a rubber ball when it is turned. Draw horizontal lines along the eyes and the nose from the front view to the profile and see how they match up. If the forehead is low it remains the same in the three-quarter and the profile.

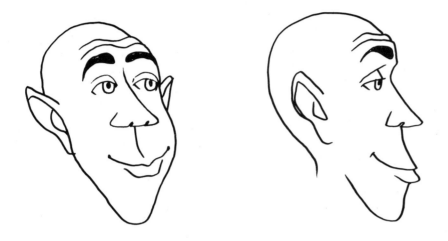

If the nose is high and close to the eyes the measurements remain constant in the three-quarter view and the profile.

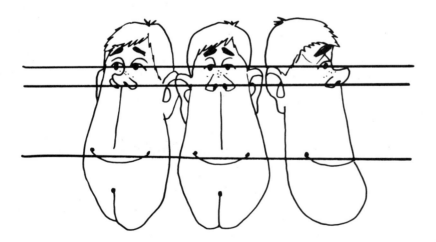
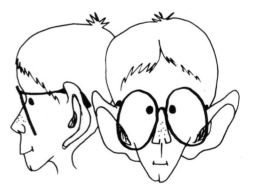

One area of difficulty for many is the placement of the ear in profile. In a front view of a normal head, the ear generally aligns with the eyebrows and the bottom of the nose; in profile this same alignment still applies, except that you have something else to deal with: the placement of the ear toward the back of the head or toward the front, nearer the face.

Normally the ear is placed about two-thirds of the way back from the front of the head. This pertains to realistic as well as cartoon characters.

Since cartooning is looser than formal drafting, the ears can be placed toward the back of the head and still appear proportionately correct.

But when the ears are placed too close to the front of the head they infringe on the face area and the drawing comes off as amateurish.

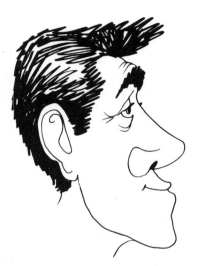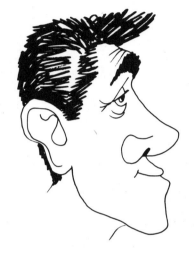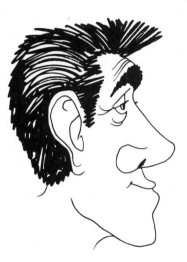

Observe how the ear placement affects this character.

Profiles can be done in a highly stylized manner by omitting some of the lines, allowing our imagination to fill in the rest.

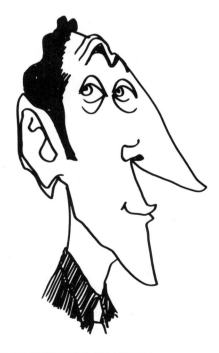

Full cheeks often obscure part of the face in profile.

This hairdo is much more pronounced in this view; it gives the profile its much-needed character.

Picasso, with his genius and unique vision, changed the face of art forever . . . as well as cartoon faces. He defied convention by placing both eyes on the same side of the head. Cartoonists eagerly seized upon this opportunity.

Here's a backward way of constructing a face from a profile; draw the profile first, then build the three-quarter or full face around it.

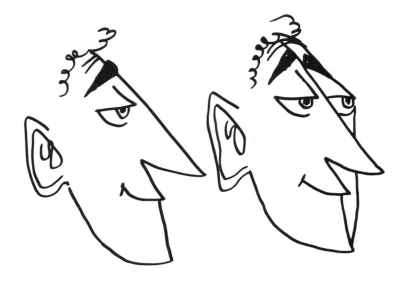

Here are a few more characters in profile to help give you the feel of working from this angle. Copy these and then do a few of your own.

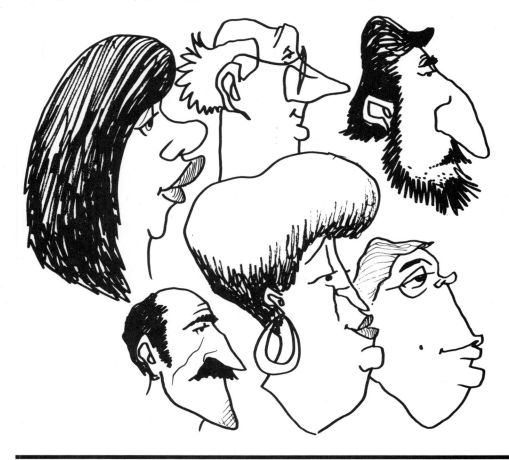

Here are some other examples of faces built on the basic head shapes discussed earlier.

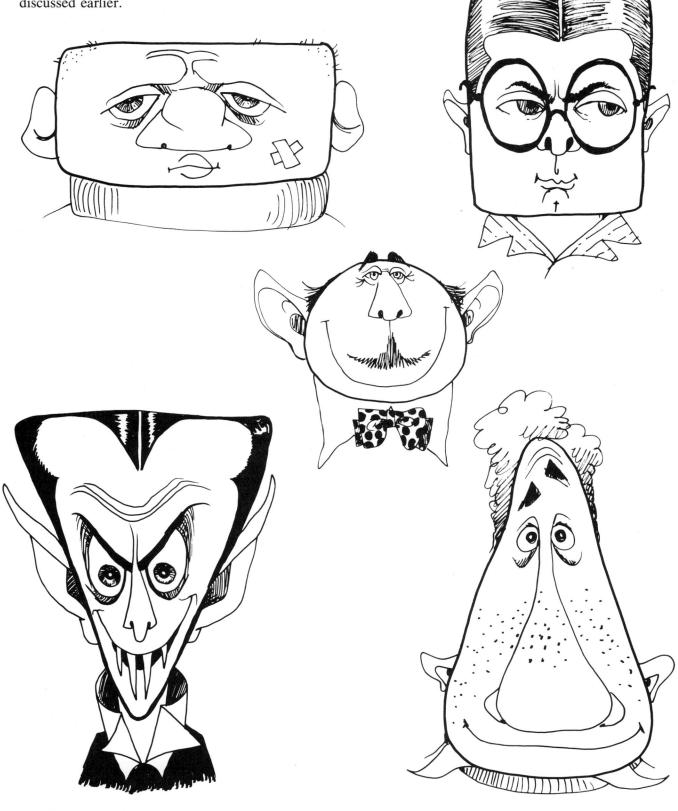

There are limitless combinations of shapes available to create always new and fresh characters. For instance, see how I've combined a pear shape with a horizontal oblong form to come up with this interesting-looking chap.

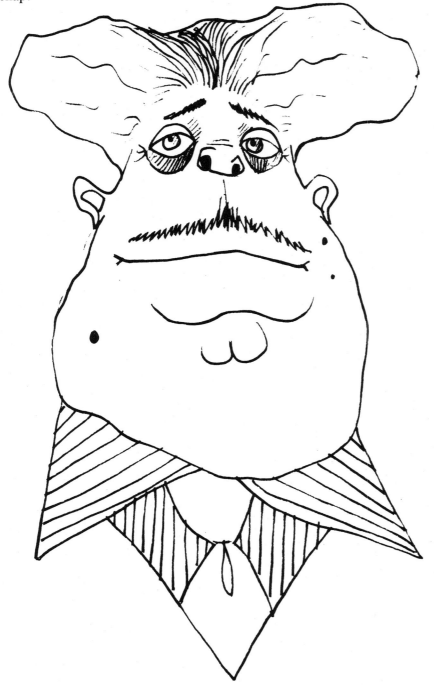

Work on these shapes until you can draw them easily, and then begin to decorate the interior with a combination of features—which are, coincidentally, the subject of the next section. So stay tuned for noses and stuff.

EATURES

Features are the creatures that inhabit the interior of our faces—all wonderful and unique in their own way. Look how wonderfully versatile a nose is; it can be a bulbous balloon or an intrusive little needle, a soft button or a great sharp beak. It can be, as Cyrano de Bergerac poetically exclaimed, ''a rock—a crag—a cape! A cape? Say rather a peninsula!''

A poet once remarked that ''the eyes are the windows to the soul.'' That may be true in poetry, but in cartooning the eyes are responsible for only a part of the expression; the mouth handles the rest. Eyes are incredibly expressive: they can be half-lidded, smoky and sensuous, wide and naive, or evil and cunning. The cartoonist must be very careful here—a half-lidded eye that could appear sexy on one hand might also look stupid or just plain tired, depending on the shape of eyebrow or mouth. It's the sum total of features and face shape that ultimately makes up a character. Each feature has an infinite capacity for individual variations, but the relationship of one feature to another is equally important. Spatial relationships are what make one face different from another; the pauses, the gaps, the areas in between. The Orientals teach not so much what goes into a painting but what is to be omitted—hence those wonderfully mystical landscapes that allow our imaginations to complete the vague excesses of Mount Fujiyama.

I will provide you with a small cross-section of basic noses, eyes, mouths, ears, and hairdos, but it's up to you to start building a dictionary of features and faces.

When you come across an interesting face in a newspaper or magazine, cut it out and save it for future reference. The artist's imagination can go only so far; we all find comfortable patterns in our work that lock out different, outrageous ideas. Keeping your eye in shape makes you aware of the incredible diversity of human beings. I have this image of a very traditional, white-bearded God sitting in the clouds, facing the problem of having to come up with yet another set of unique features, not to mention fingerprints. God knows how he does it!

These noses are based upon some shapes we used earlier: circle, triangle, square, and so on. All we have to do is sketch out the shape, add the nostrils (these look not unlike apostrophes), and then place the nose in a face and start building around it.

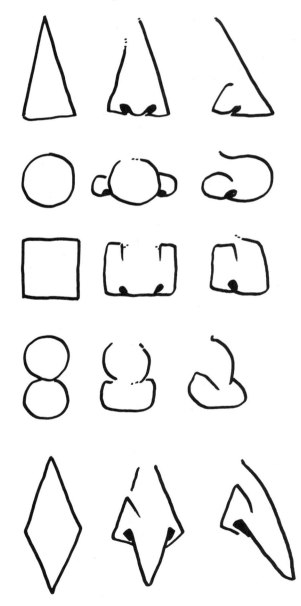

This brings up a question that's thrown at me all the time: what to draw first—the nose, the eyes, or another feature? There's no simple answer; it's a highly subjective choice. However, if you are aiming for a certain type of character, a prying, snoopy spinster, for example, it would make sense to start by giving him or her a sharp beaklike nose (stereotypically, it goes with the territory). But there is no right or wrong way when it comes to designing characters. You might just want to go against type and make a prying gossip out of a fat, cherubic face whose primary feature is a pursy mouth. If it works, it works. No matter what, stay on the alert for new faces; never let your powers of observation diminish. Using your feature and face dictionary will be of enormous help if your imagination flags.

Here are some different treatments of eyes.

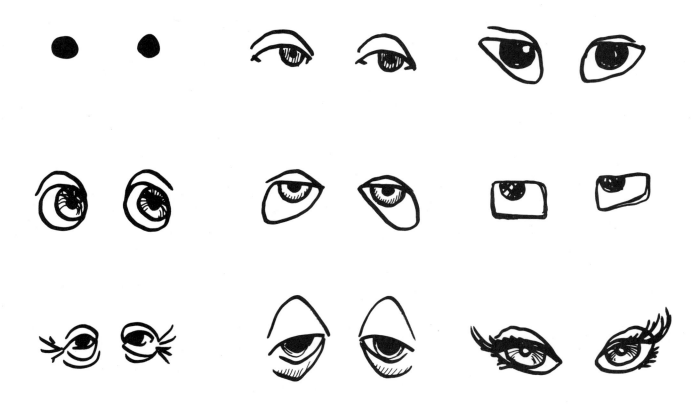

Let's take one pair of rather nondescript eyes and dress them up in an assortment of brows so you can see how radically it changes their expressions.

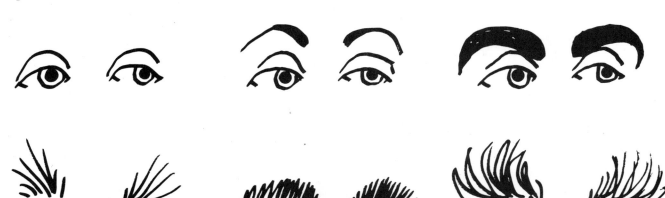

Now draw your own pair of eyes, even if they're simple dots, and try different brows to achieve various effects.

Here are a few mouths for you to practice with.

Look at your mouth in a mirror and draw it as you speak, laugh, and make all sorts of outrageous faces. Your mirror can provide endless inspiration.

The ears, like the hair, help to frame the face. It's amazing how a pair of oversized ears can change a handsome person into a comical one. Here are some examples that show how different-shaped ears can change the personality of a head.

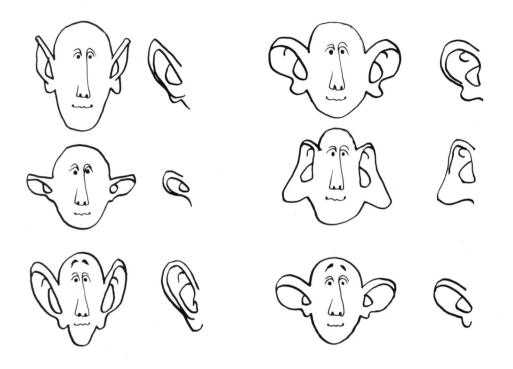

Here's a face to which I've affixed a pair of 747 flyaway ears. Note the difference it makes.

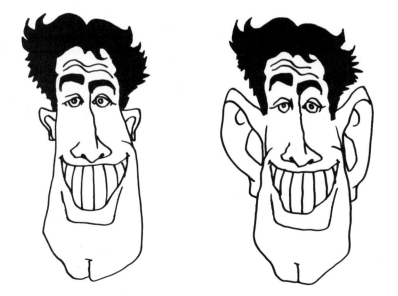

Now watch as larger ears transform this rather hoydenish but appealing girl into more of a soubrette.

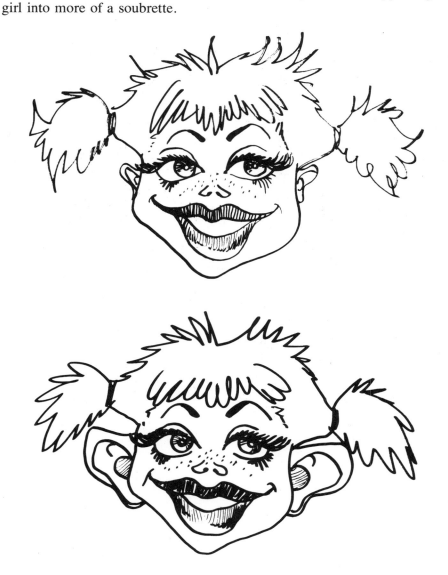

Ears can be handled many ways in a cartoon; an ear can be merely a suggestion, a small semicircle like a comma, or an intricately structured shell. Here's a group of ears from simple to more complex; try copying them and find the ones that you can draw comfortably and easily.

The basic shapes of ears are a C shape, a lopsided 3, or a 7.

Hair frames the face. Many people (men and women alike) choose their hairstyles more carefully than their clothing. When you hear of the billions of dollars spent each year on hair-care products, you'll realize the enormous importance hair plays in our appearance. Here's a rather nondescript bald guy.

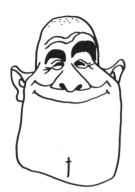

But watch the metamorphosis as I change his hairstyle.

And when I add other accoutrements . . .

 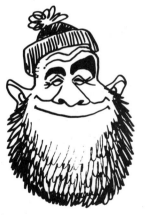 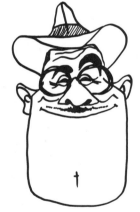

See what various hairdos do to this lady.

And different styles give this simple little chap badly needed visual interest.

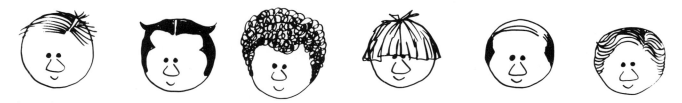

Certain magazines are filled with photographs of feminine hairstyles. Check them out and add examples to your dictionary—you'll find them an invaluable reference tool. You needn't go into great detail; hair can be a mere suggestion. Great artistic skills aren't required to convey a head of hair. Here are some simple ways to deal with drawing hair.

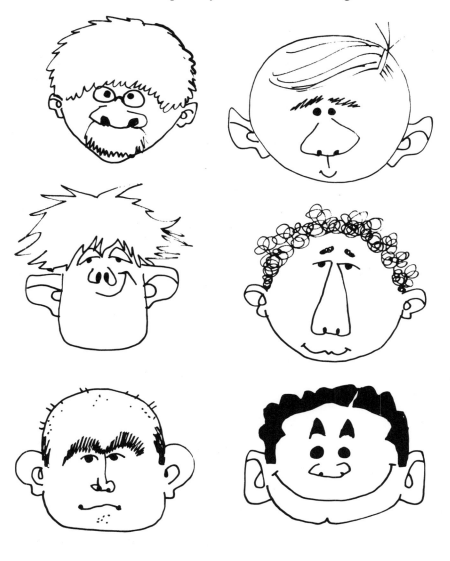

Okay, it's mix-and-match time. Take the head shapes I've shown you and start combining them with the features in different ways to create some of your own characters. (This is sort of a "one from Column A, one from Column B" approach, just until you find your own way.) If you feel that some of this is beyond your grasp at this point then read on. . . . I have a technique that will break down a few of those barriers and put you on the road to successful cartooning.

ORMS

Have you ever sat and stared at a design in a rug or on wallpaper and then begun to see faces and/or figures appearing in the patterns? That's your artistic imagination at play, taking abstract shapes and moving them into logical, preconceived patterns. Now the trick is merely to harness those creative impulses and get a little cooperation going between your brain and your hand. There are many movements we do naturally, so automatically that we take them for granted—like brushing our teeth, tying our shoelaces. They were difficult for us initially, but after days, weeks, and sometimes months of trial and error we were able to apply the correct hand-eye coordination. The tasks finally became second nature, so they no longer required conscious thought.

I believe the same principle can be applied to drawing. I learned to draw in a most unorthodox (read: crazy) manner; as a child I began sighting down my index finger with one eye and tracing around people, objects, buildings, everything in view. After a while I moved that hand over about a foot to a drawing pad while my eyes stayed fixed on the subject, and before I knew it I was drawing. This technique won't work for everyone but it did for me. It was the constant repetition: I didn't really know it at the time but I was sharpening my powers of observation while training my hand. When the movements became totally fluid and comfortable I was ready to start drawing. If you deal here with movements you are comfortable with, you'll be that much ahead of the game. For instance, we all draw every day, when we write our names. You may call it writing but you are in fact drawing shapes (also called ''letters'') that represent sounds.

Let's take some of these shapes, these letters that we draw every day, and try to use them as a jumping-off place to cartoons. And for now don't think of this as drawing—we are merely ''playing'' with these abstract shapes we know as letters.

Let's start at the beginning with an A.

If I were to ask you to draw a nose and the two lines that flank the nose you might have difficulty, but if I asked you to print an A you could do it. This simple shape can easily act as the basis of a cartoon face.

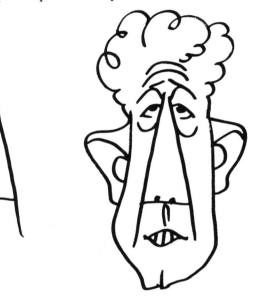

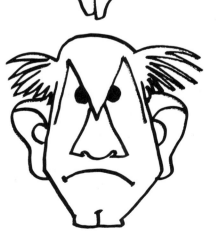

An M can also be used as a nose.

Or as an angry brow . . .

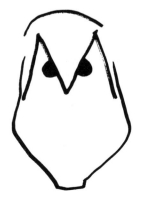

An H works as a mouth.

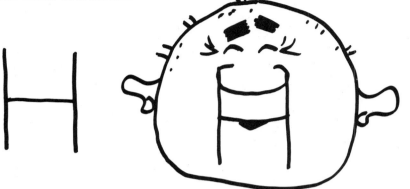

This W works very well as a collar.

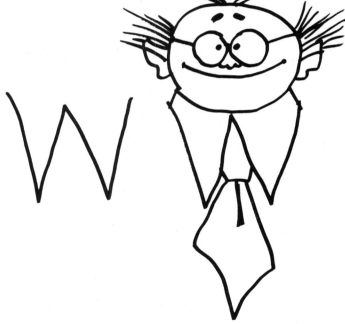

Print a B, lay it on its side, and it can be used as a pair of eyes.

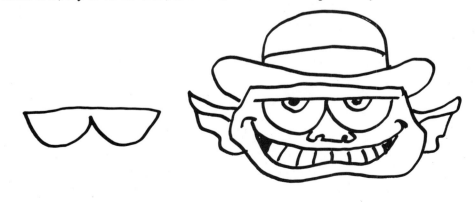

And we needn't limit ourselves to letters. Here's a face born of a question mark.

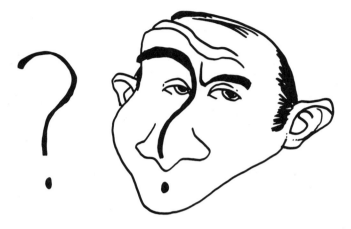

Numbers lend themselves to this exercise as well. Here's what can be done with a number 2.

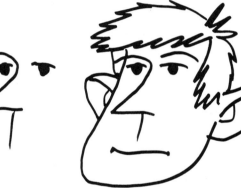

And an 8 . . . Lay the 8 on its side and it works as a mask.

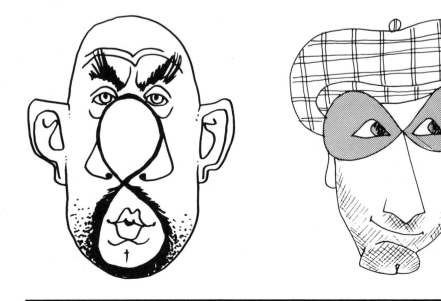

A deck of playing cards inspired these transformations.

A spade . . . becomes this. A diamond . . . turns into . . .

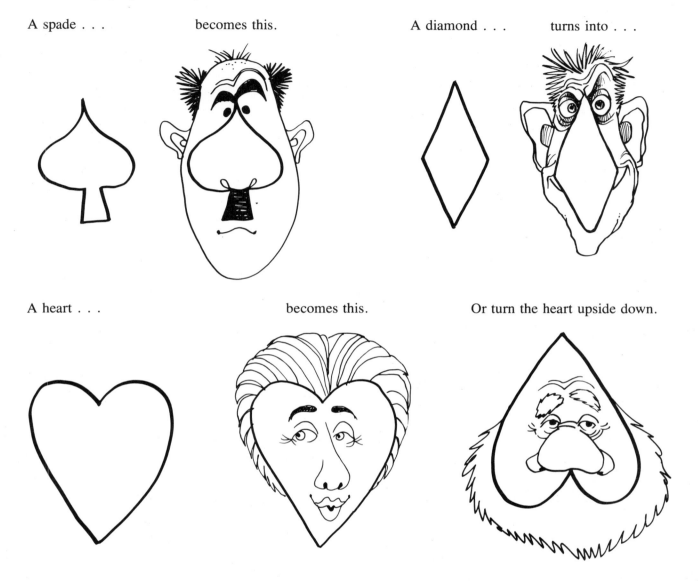

A heart . . . becomes this. Or turn the heart upside down.

Here's an easy shape to draw—a light bulb.
The round portion becomes the head and the neck—the neck. Or you could use the entire bulb as the head.

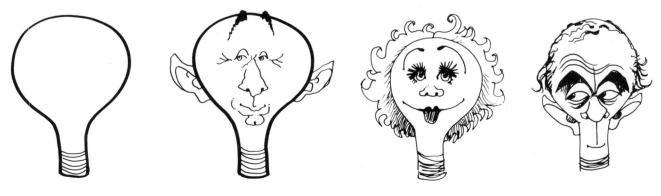

A teardrop shape is quite easy to draw but just look at all the things it lends itself to:

A clown . . . Or a man's head-and-neck combination.

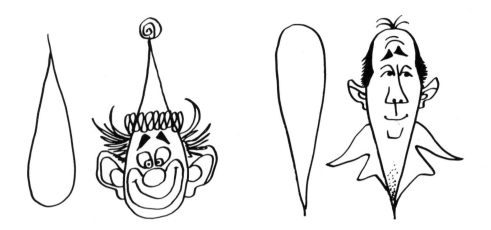

This one shape can be used for a fish, a stork, or (with some minor modifications) a rat.

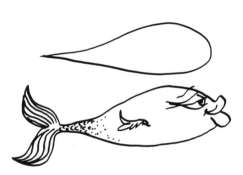
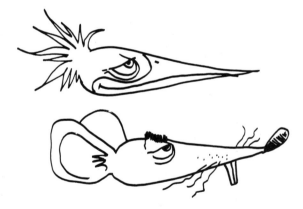

Extend the teardrop on the other side and you have opened up new opportunities.

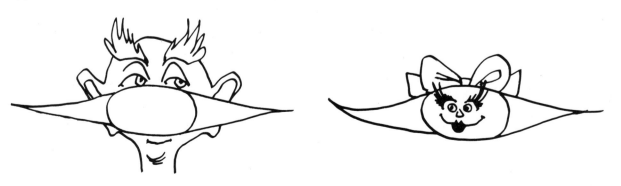

And look what can be done with the simple shape of a hairpin.

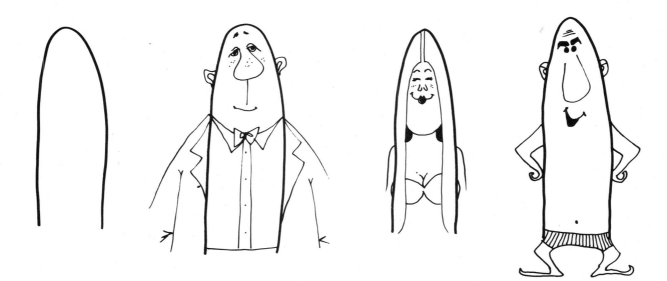

By taking extremely simple shapes and adding a dash of imagination we can produce an incredibly diverse gallery of cartoon characters. And we've only scratched the surface; you can find dozens more everyday shapes that will serve as the beginning of a cartoon. It's out there all around you—all you have to do is look for it.

Here are a couple of faces constructed from combinations of simple shapes, a rectangle and two circles.

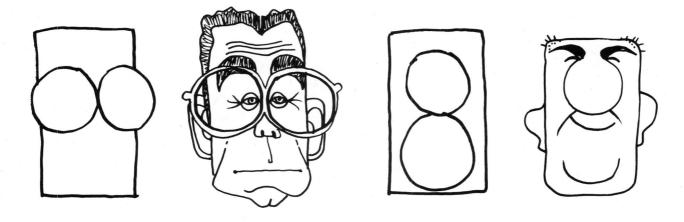

Now let's build a cartoon head with a few of these shapes. We'll start with a circle, place a triangle in its center, and then lay two Ds on their sides.

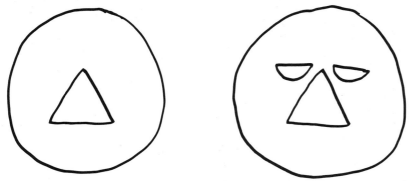

Bring a line down from the nose to a small C shape for the mouth, and put in two exclamation points for the eyebrows.

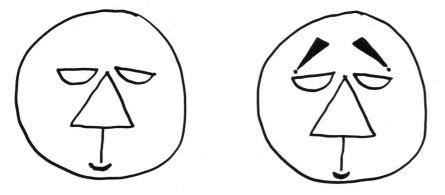

Use a W for the collar and two 3s (one backward) for the ears, and fill in the Ds (the eyes) with smaller Ds for irises, and periods in the middle of the smaller Ds for pupils.

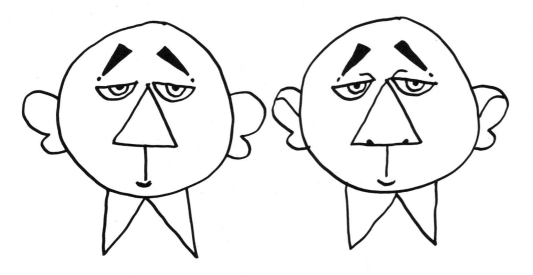

Voilà! With a few embellishments we end up with this character. Not bad for a simple construction using familiar shapes.

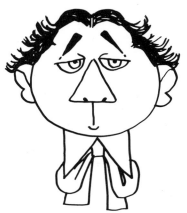

And you needn't be restricted by the shapes I've suggested here; you don't have to be able to draw a circle. Anyone can draw a loose, fried-egg shape, and these can make wonderful characters. For example . . .

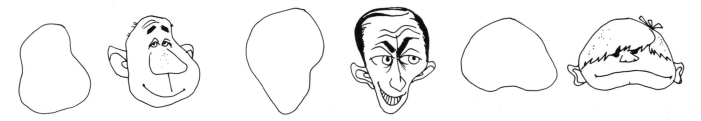

Remember that pieces of art take their shape and definition from the artist's imagination. One of Picasso's most charming and humorous pieces of sculpture was of a mother baboon and her baby whose heads consisted of pairs of toy cars placed bottom to bottom, facing in the same direction. The front windshields became eyes, and the mouths were the radiator grills. It's all there in your imagination waiting to be tapped into, so start playing with forms and see what ordinary, everyday things you can transform. The results will surprise and encourage you.

And of course, the more you sketch and doodle, the sooner you begin putting pencil to paper, the sooner you will feel relaxed and comfortable with the drawing process. Take your sketchbook with you everywhere: in line for a movie, in restaurants, at the park, wherever human beings are found. You'll soon learn the art of ''stealing'' body attitudes, expressions, costumes; the entire spectrum of human emotions, tastes, and idiosyncracies is out there waiting for you.

Talent is an elusive thing that must be nurtured by perseverance and application. You will be using new muscles, a new network of coordination that will occasionally send scrambled messages to your hand. You'll eventually sort them out, but it takes patience and time. And once you begin to see as an artist you'll never see anything quite the same way again. So draw . . . draw every day as much as you can. It's a thoroughly pleasurable way to pay your dues so that you can join that exclusive club—the cartoonists of the world.

EXPRESSIONS

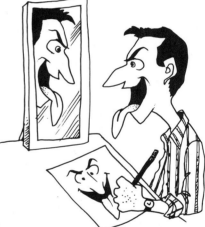

Expression is the fire that lights up the face and brings it to life. Without expression the face would be a mass of flesh devoid of character. It takes a very small thought to produce a discernible change in facial muscles. That's something I learned very early as an actor: If you think it, it will be there.

The best way to start drawing expressions is to observe yourself in the mirror. But instead of making an angry face, think an angry thought and see what happens to your face naturally, without any preconceived notion of what "angry" looks like. Do the same with joy, hysteria, complacency, fear, and so on. Every human emotion is there in your mirror waiting for you . . . if you choose to use it. If you happen across a wonderful photo of an outraged umpire or ecstatic award-winner, file it away and haul it out when you need that particular expression.

On the next few pages you will find a wide range of expressions to use as a yardstick. Use these and, as an exercise, apply them to different characters of your own creation.

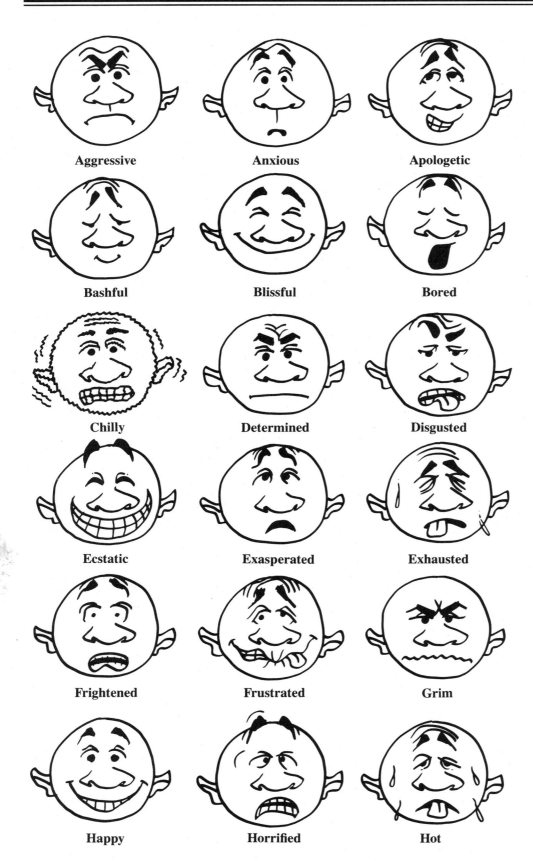

Aggressive Anxious Apologetic

Bashful Blissful Bored

Chilly Determined Disgusted

Ecstatic Exasperated Exhausted

Frightened Frustrated Grim

Happy Horrified Hot

Hung-over

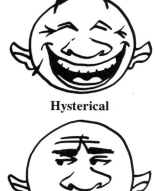
Hysterical

Indifferent

Innocent

Jealous

Lascivious

Lovestruck

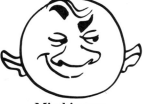
Mischievous

Optimistic

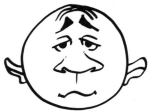
Perplexed

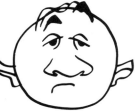
Puzzled

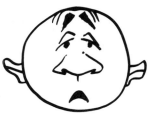
Regretful

Sad

Sheepish

Shocked

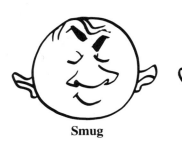
Smug

Surly

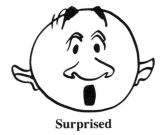
Surprised

Here are some samples of a few expressions as reflected in more worked-up faces.

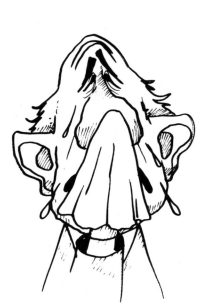

Weeping

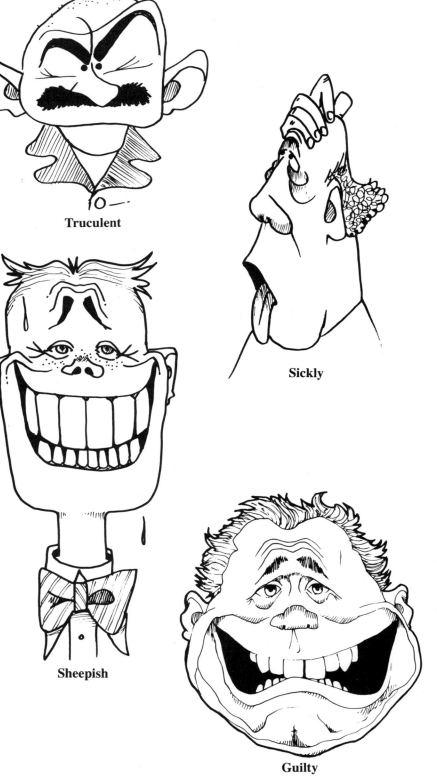

Truculent

Sheepish

Sickly

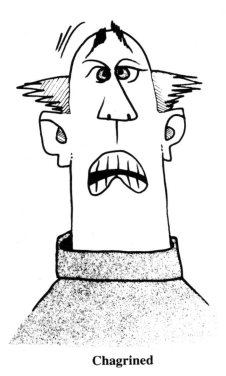

Chagrined

Guilty

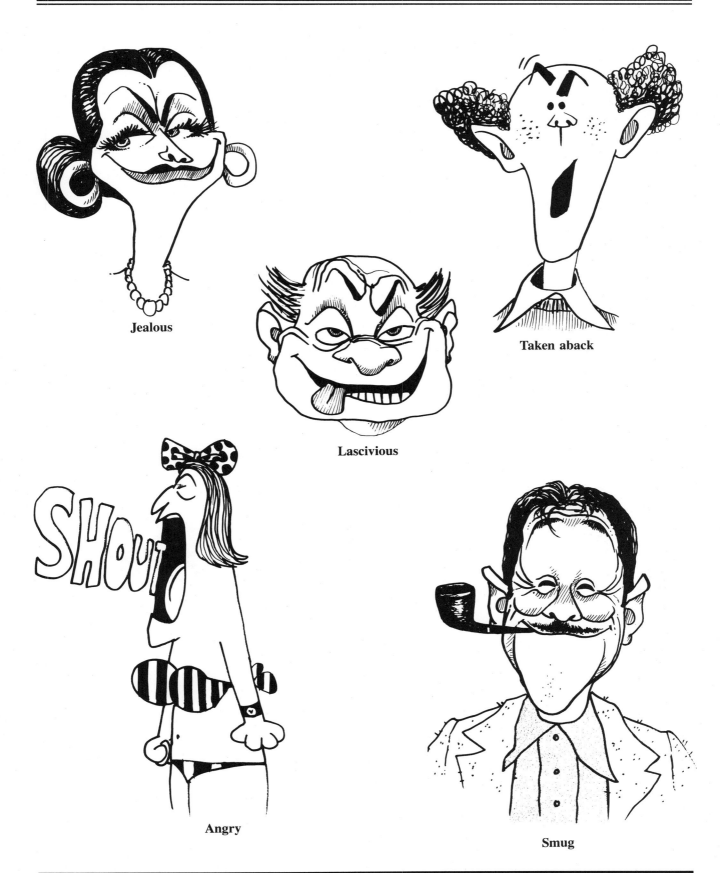

Jealous

Lascivious

Taken aback

Angry

Smug

Of course, expressions in cartooning can be as broad as you wish. For example, look at these three stages of fear: they all work—it merely depends upon how far you wish to go.

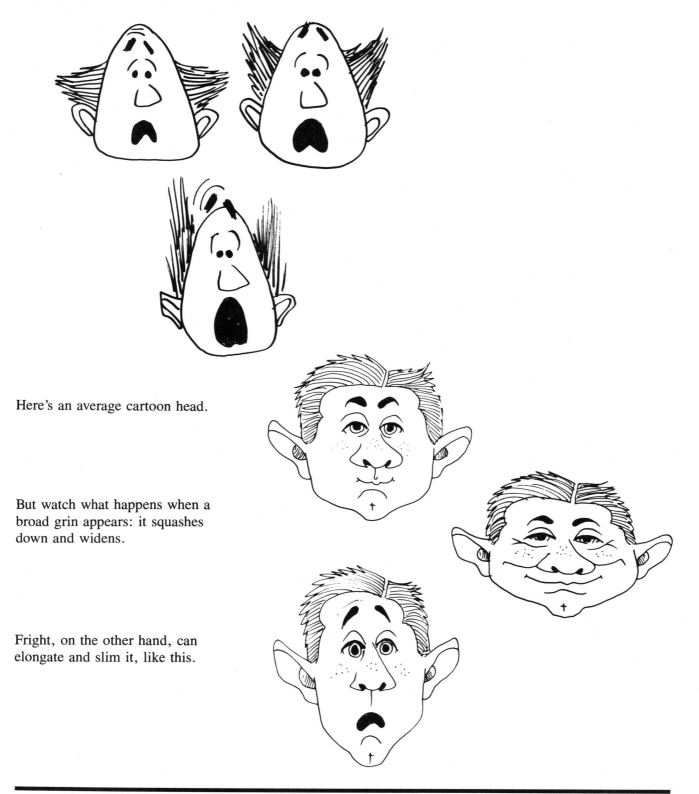

Here's an average cartoon head.

But watch what happens when a broad grin appears: it squashes down and widens.

Fright, on the other hand, can elongate and slim it, like this.

In cartooning this kind of exaggerated expression, imagination with line helps to create animation, spirit, and a sense of movement.

Now let's take a look at some expressions in profile. Notice what happens to the thrust of the neck as these characters react.

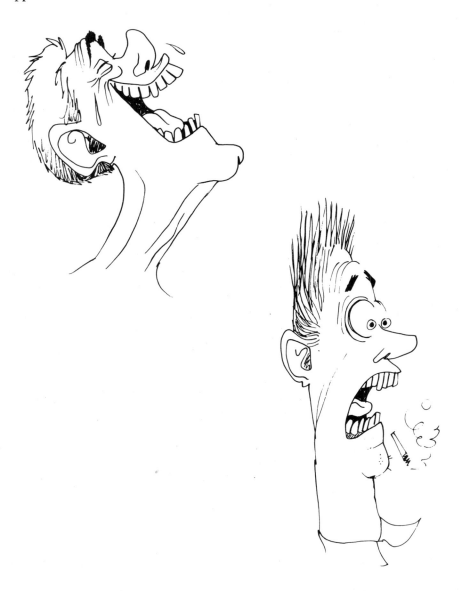

Now it's time for you to experiment again. Create your own character and then move it through a whole range of expressions. If, when you've finished, you haven't communicated the sense of hysteria or frustration or whatever you're trying for, keep on until you are satisfied that anyone who looks at the drawing will be able to read the intended emotion instantaneously.

Now let's move on to an equally expressive area—the human body.

FIGURES

Next to the face, the human body is the most expressive tool for the cartoonist. Body language in cartooning has been pushed to the outermost extreme, as far as it can be taken in any art form and still be quickly understood by the viewer. The basic concept of the ideal or normal human figure can be found in Michelangelo's figure drawings (though he was guilty of subtle caricature of the human form; certainly his bodies were exaggerated—but toward the sublime rather than the ridiculous). In cartooning, proportion is important only in that it helps to convey a specific action, movement, or attitude. We cartoonists are allowed incredible liberties.

The normal or average body is figured at about eight "heads" high.

If we held to that measurement in cartooning the humor would soon evaporate. This character, for instance, is proportionately acceptable for a cartoon though he's only five heads high.

This is happy news for the beginning cartoonist—no strict anatomical principles to absorb, no rigid measurements to adhere to. Still, the human form, even in cartooning, must be respected to a degree; shoulders still brace the neck, arms dangle from the shoulders, and legs support the body. We have the latitude to employ outrageous distortion, but paradoxically, it must be a controlled, uniform distortion. In other words, you may stretch the character's body to extremes to suit your needs as long as it still remains recognizable as a human form.

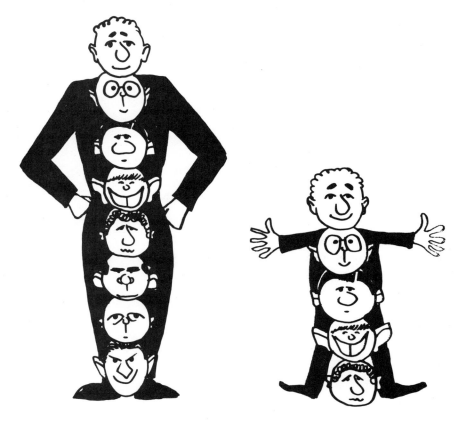

The differences between the male and female body in cartoon art are minimal; men usually have broader shoulders, heavier eyebrows, and more muscular arms.

Women have slender waists, shapely legs, and breasts. That's about it in this art; other than these, hair and clothing are the primary factors in separating male from female.

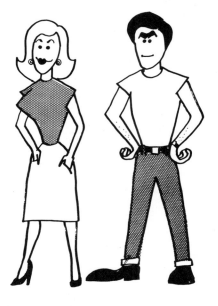

Most cartoon figures can be constructed from a series of simple geometric shapes (yes, here are those infernal shapes again). You can build a figure from a series of ovals or use circles, squares, and so on as the basis for the form.

Here's a sketch based on a circle, with a smaller circle for the head.

As you can see, all I've really done is to add arms and legs to this circle. The body is made up almost entirely of the circle itself, while the head is no more than a small bubble atop a larger bubble. Few anatomical principles here, it's simplicity itself. Cartoonists, as you can see, get away with murder.

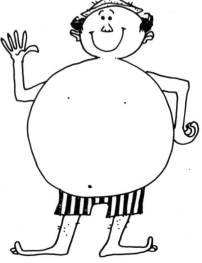

This weightlifter is built around a triangle. Since broad shoulders and narrow hips seem to be the convention for muscularity and fitness, you'll find yourself using the triangle for most of your heroically proportioned figures.

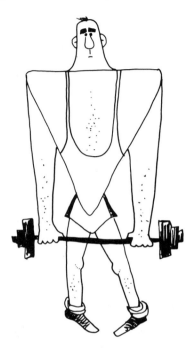

This policeman's body is based on a square, with a rectangular head added.

A triangle is a solid basis for a figure profile.

You can also use the triangle to come up with a guy in better condition.

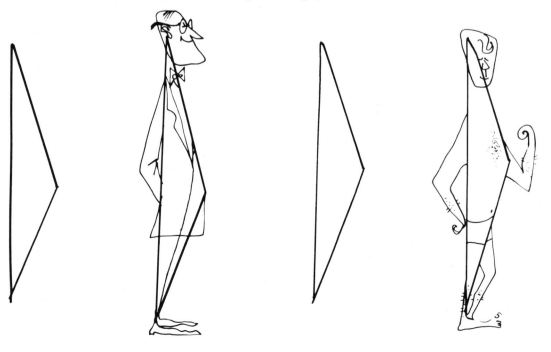

Here are examples of figures created from various shapes: oval, circle, triangle, pear shape, square, and vertical rectangle. (A peanut shape works nicely for a shapely woman.)

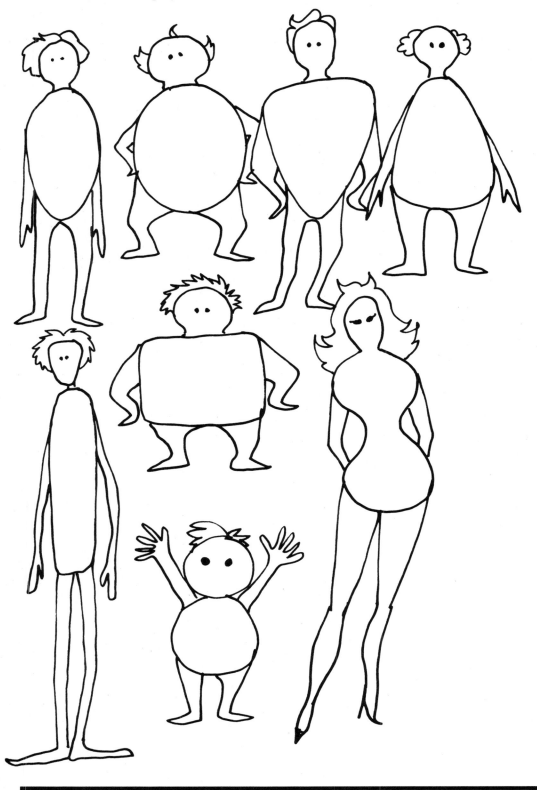

Cartoon characters, whether they're in a strip or a single-panel cartoon, aren't always in extreme action. They do a lot of standing around, so it's a good idea to start developing a feel for this position. Arms behind the back, weight shifted onto one leg, hands thrust into the pockets—explore the possibilities.

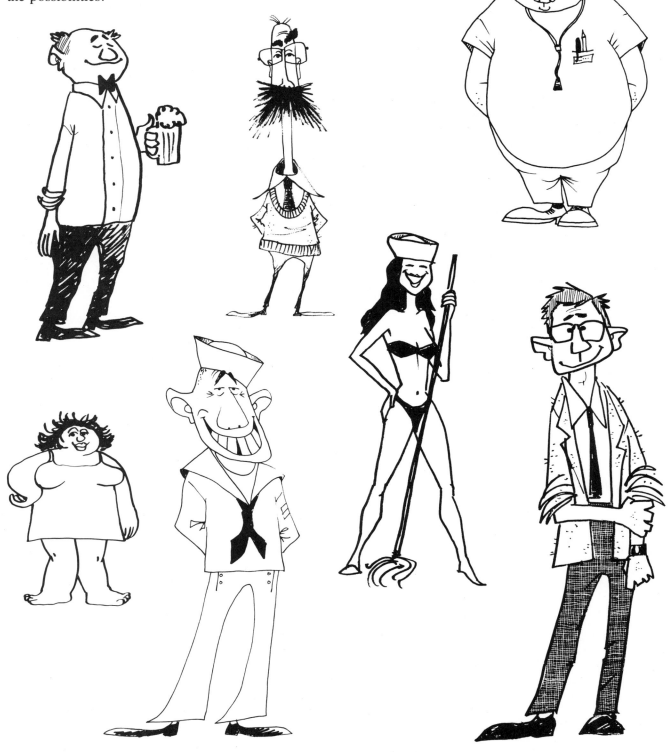

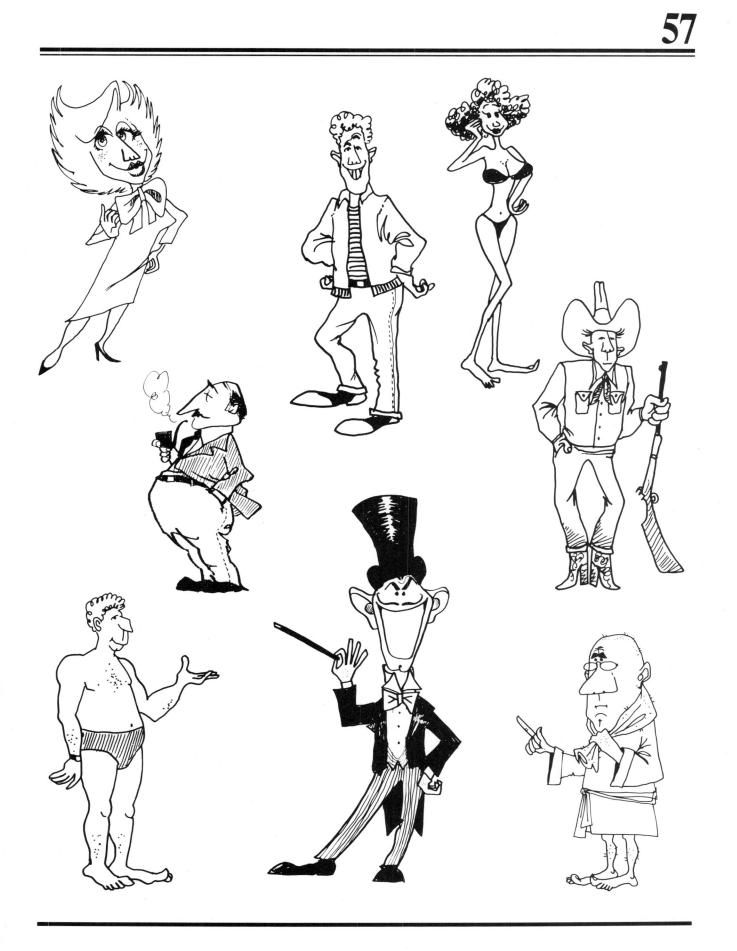

58

Of course the complete cartoonist has to be able to draw characters in action as well; we have to make our figures move. In the world of cartoons, people strut, they amble, they saunter . . . they almost never just walk.

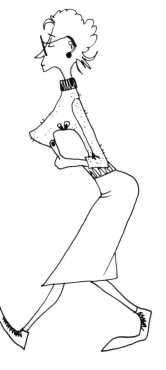
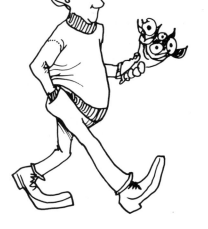
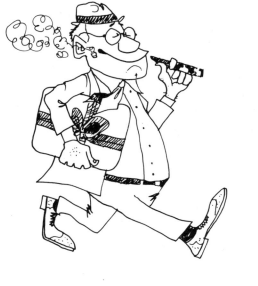
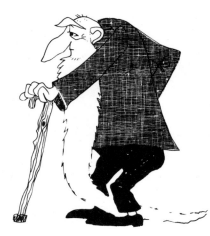
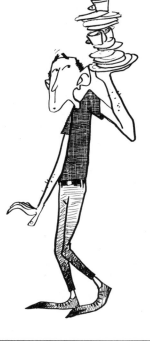

And they do a lot of sitting.

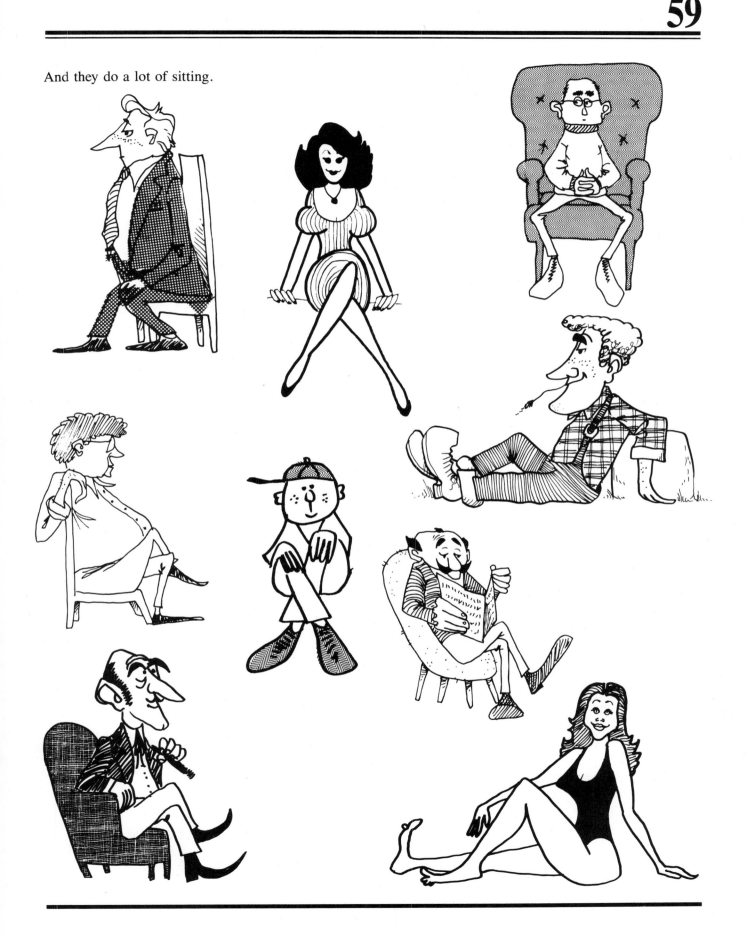

When a character gets angry, his entire body has to reflect it.

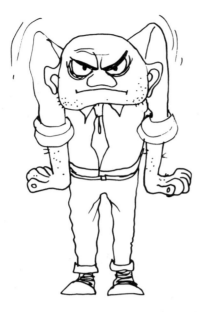

When a character yells, all of his energy emanates from that cavern of a mouth. Note how all the lines radiate from the source of the sound.

When a cartoon figure is cold, he entwines his arms and legs into impossible positions just to get warm. Everything should be overstated for comic effect.

When he laughs his body collapses into hysteria.

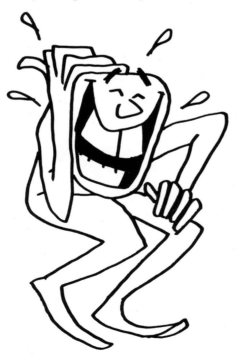

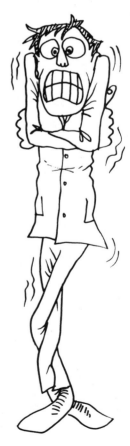

Sleeping seems like a dull activity to draw, but the cartoonist should be able to infuse comedic life into the most mundane of things. Everything can be (and should be) exaggerated.

The normally quiet business of painting can be turned into an energetic activity by giving a swordsmanlike stance to the artist.

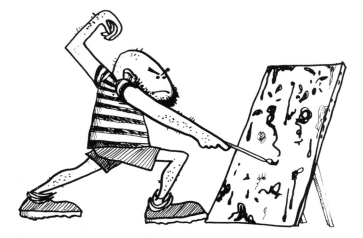

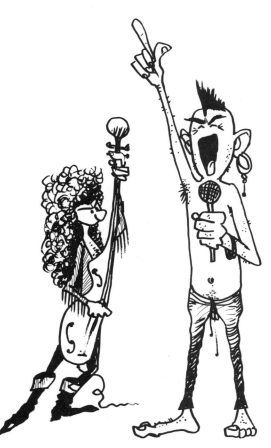

Rock singers have built-in color and line so you don't have to create much visual interest. They've supplied it for you.

When doing a preliminary sketch for more energetic action figures, first find the *action line,* the one line that thrusts the figure into movement.

In this drawing the action line is the large V going from the left leg (the one touching the ice) and then bending backward at the upper body toward the head. This sweeping V is what gives the figure an impression of movement. The windblown scarf and hair help, but the vital element is the underlying action line.

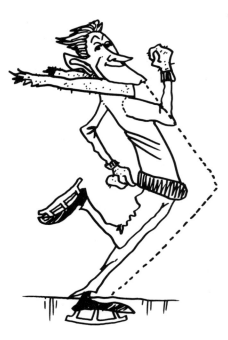

Watch how the action line changes on this bowler during this sequence of drawings.

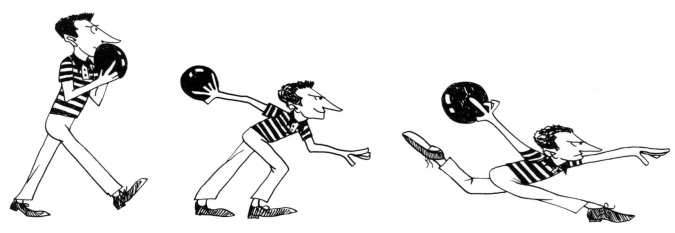

These amorphous figures are involved in diverse activities. Find their
action lines.

Always exaggerate. When you want to show a character leaning, don't have him lean like the figure on the left. Make him *really* lean like the one on the right.

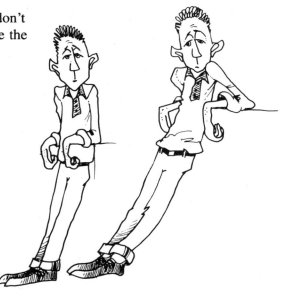

A runner doesn't just run—he tears!

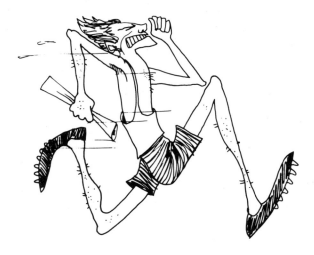

Or he drags at the home stretch.

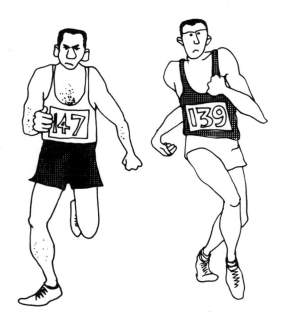

And a diver doesn't just dive: he either slices smoothly into the water like a knife or does a comedy dive like this guy.

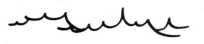

Here's a preliminary sketch with a thrusting action line. . . .

And here's the completed drawing. You can see how little is actually required to convey the tension of the figure.

Dancers provide their own clean action lines. See how easy it is to spot the action lines in these drawings.

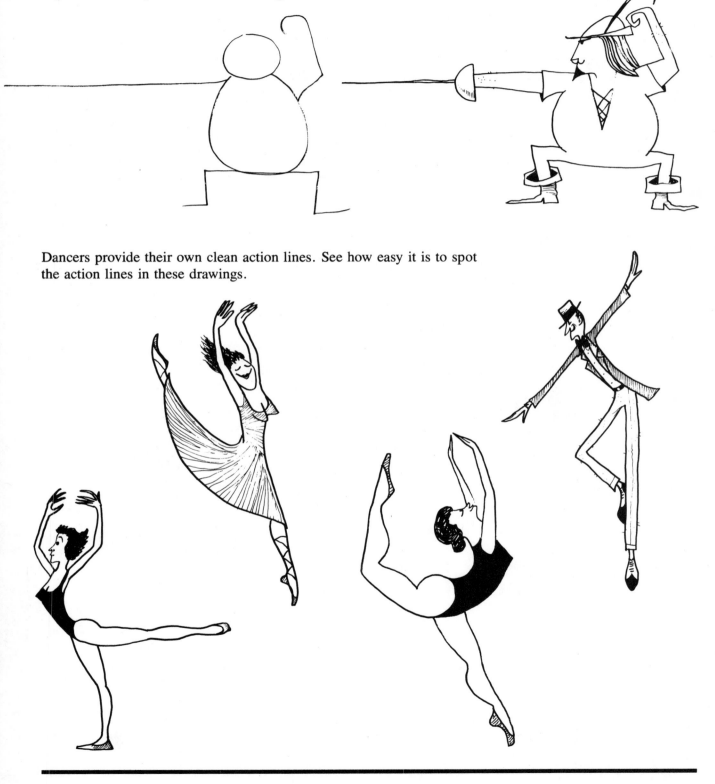

The world of sports is perfect for overstated action figures. When I want to sketch and have no models (which is all the time) I pick up back issues of *Sports Illustrated* or the sports section of the Sunday paper and find a lot of wonderful material. Of course I always file it away in my dictionary for future use. You can build up a file of movement so complete that you'll have to use a model for only a few, very specific poses. (Beg your parents, children, brothers, sisters, husband, wife.) I also recommend issues of *GQ, Vogue, People, Life*—anything that has pictures of people doing what people do. I particularly like *GQ* and *Vogue* because the models are posed standing around casually conversing and interacting in offbeat and interesting ways, but since they are posing for the camera, their positions are slightly exaggerated, which makes them easier to caricature. This is what cartoon characters do a lot of, so I find it very helpful—and it opens up new ideas to me. These magazines are also handy for learning to draw clothing and the fascinating way it drapes and wrinkles.

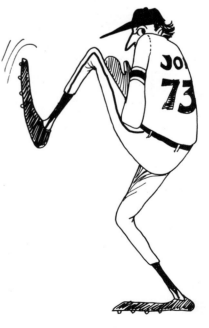

Here are some examples of figures involved in sports. Note the exaggerated action lines and how I've stretched the proportions far beyond the limits of reality.

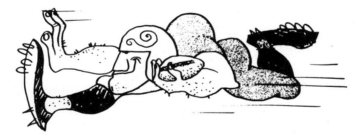

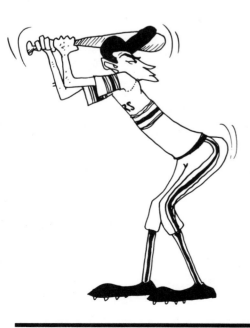

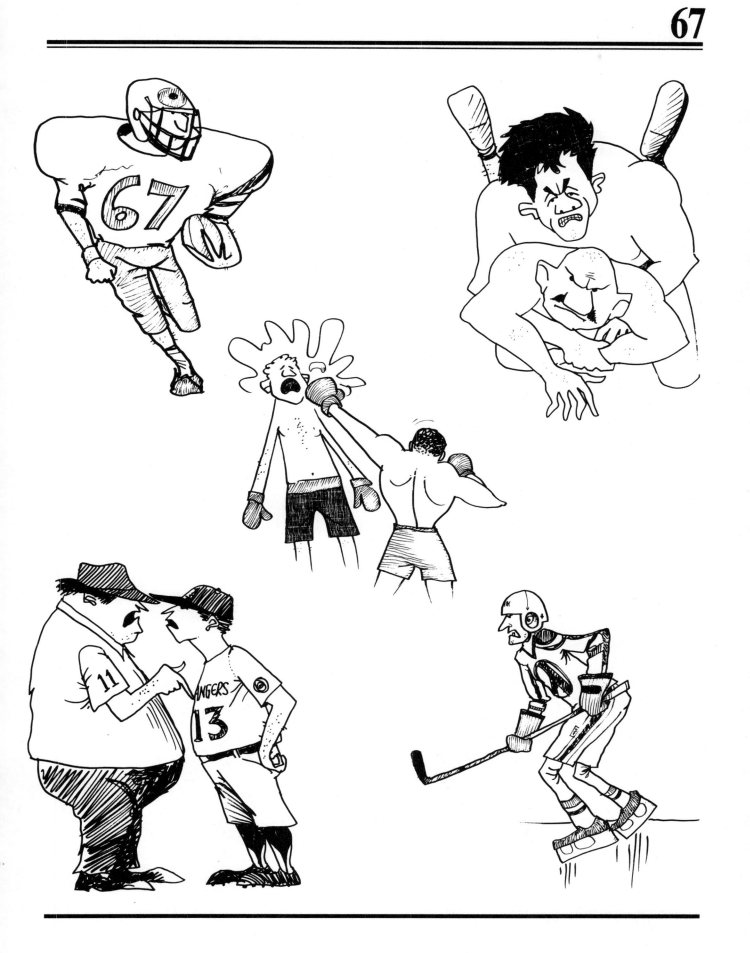

Since cartooning is an art that must communicate instantly, clothing is of utmost importance. It immediately informs the viewer as to whether the character is wealthy or poor; nerdy or cool; yuppie or hippie; punk rocker, businessman, or bum; cook or accountant. I remember a wonderful photographic feature in a magazine a few years ago: a few derelicts were taken off the streets, cleaned up, and dressed in the finest clothes. The metamorphosis was astounding—these indigent, homeless people ended up looking like Wall Street brokers. Clothes can indeed make the man and the woman and, above all, the cartoon character.

Let's dress this little guy up in a variety of outfits just to illustrate how one character can assume many roles.

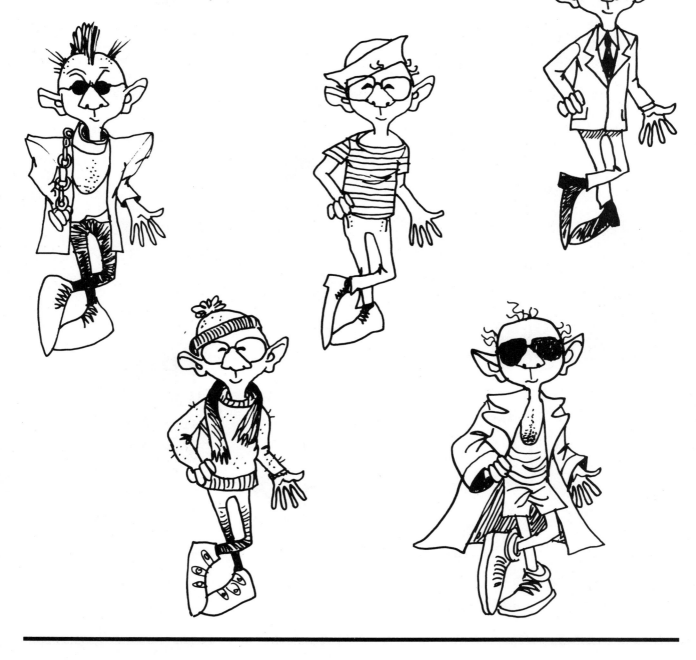

And watch how this man changes professions as we dress him in different costumes.

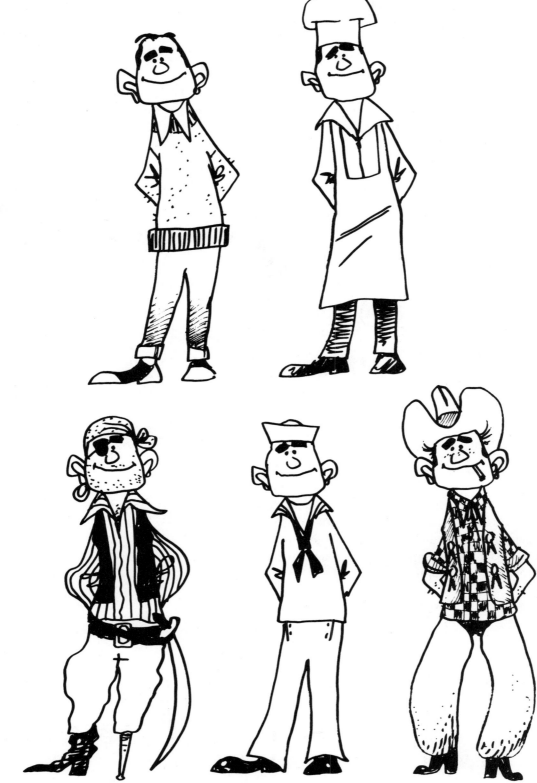

Hands and feet are extremely important aspects of the cartoon figure, though some artists underestimate them. In cartooning, hands and feet can be simplified and still used as the expressive tools they are. Realistic representation is not easy but, as usual, cartoonists have a pretty easy time of it. Many cartoonists cheat by having their characters stuff their hands in their pockets or hold their hands in permanent fists. A cop-out. Hands are so eloquently expressive and helpful in developing a cartoon character that I urge you to include them in your bag of tricks. Sit at your drawing board and sketch your free hand in all sorts of positions: holding things, pinching, drawing, writing, pulling—the variations are endless. But persevere, it will be time well spent.

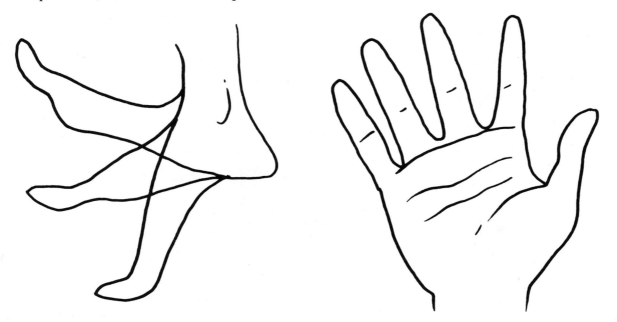

To draw a basic hand begin with a square. From a center point at the bottom of the square draw five lines radiating outward from the same point. Encase each of the lines in a hairpin shape and you have a simple, easy cartoon hand. Fold the hairpins over and you've made a fist. Stick the index finger out and it's pointing.

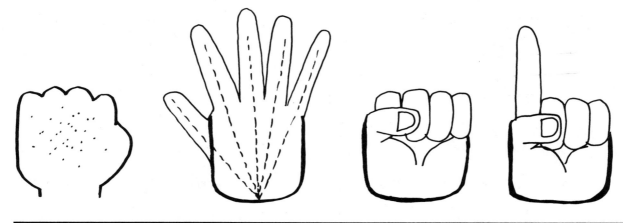

To show how important hands can be, I've drawn a face with the same expression and added hands in three different positions. Note how the different hands change the character from thoughtful to confused to slightly worried.

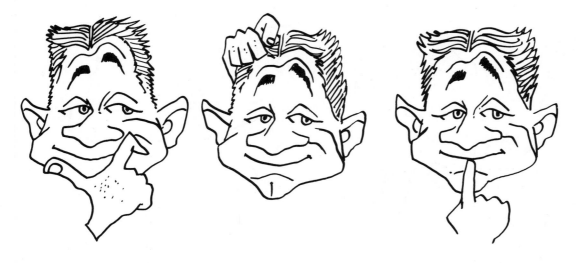

See the vital part the hands play in this drawing of a concert pianist.

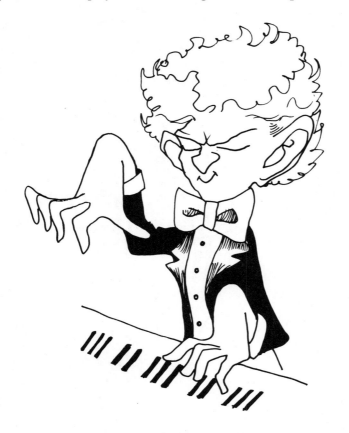

Here are various hands in different positions. Start by copying these, and then do variations on your own hand.

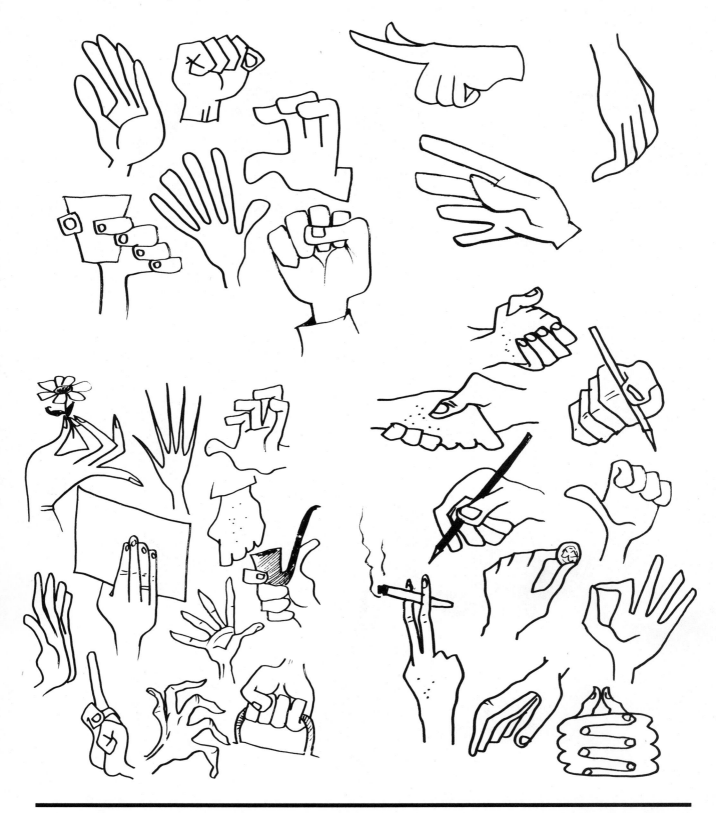

Feet are much easier to deal with than hands. For one thing, they're normally covered by shoes, which are infinitely easier to draw. Here are some feet, shod and bare, to start you on your way. See how simple the front views of bare feet are? Nothing more than an ankle with a bunch of toes.

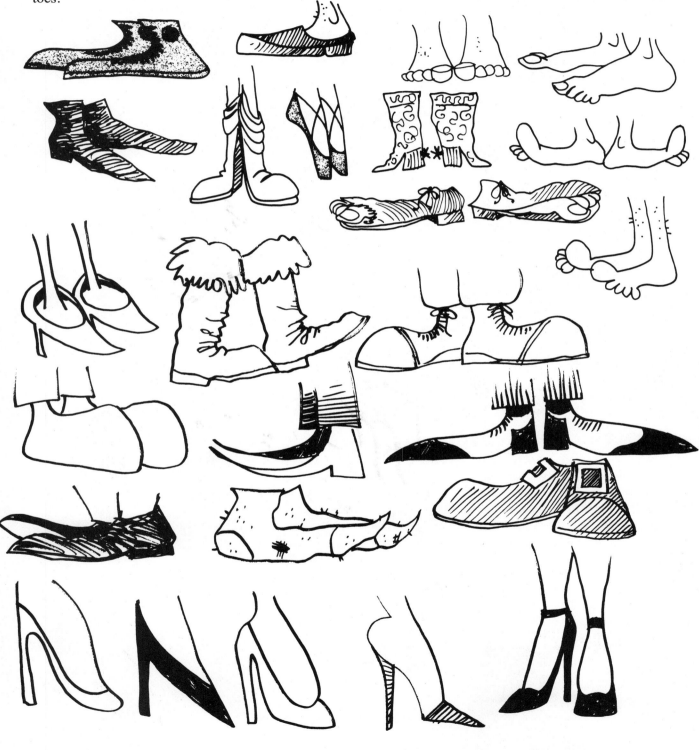

Some people have difficulty drawing children, possibly because children are still rather unformed. Their little faces haven't found their features yet. Still, each of these tiny people has enough character and individuality to be captured by the perceptive cartoonist. Just look at the remarkable success of Charles Shultz and his *Peanuts* gang: each simply drawn character has captured our hearts and become virtually a three-dimensional personality.

When you draw a cartoon infant, make its body just about the same size as its head. This immediately says *baby*.

To draw a baby's head we have to altar our proportional scale; give the child much more brow, crowd his little features into the bottom third of the head, and set his eyes wide apart. A baby's eyes needn't be completely defined: as shown in the illustration of the child with the rattle, well-placed dots will do just fine.

As the infant grows, the head remains the same size while the body slims down and lengthens, informing us that the baby has become a toddler.

Here are some kids with highly individual faces and bodies. I've applied the same methods of differentiating that we have already learned for adults, dressing them in different clothes, giving them different hairstyles, and varying the spatial relationships in the faces.

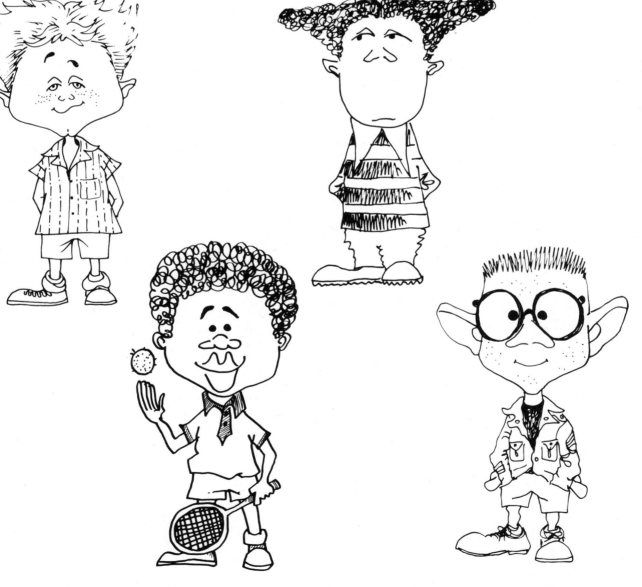

And here's a slightly older sister thrown in for good measure. As you can see, she is on the brink of womanhood; so I kept some of the childish dimensions in her face but let her expression and body language tell us she's on her way to becoming an adult.

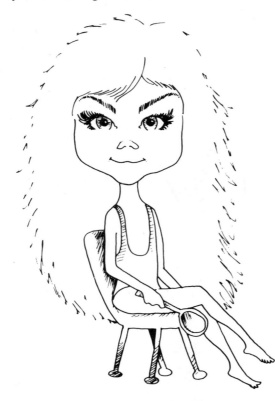

Children are by nature very expressive; they have dynamic mood swings, and it's important to be able to characterize them. I'll take the first little boy through a series of expressions to demonstrate how emotions can register in a child's face.

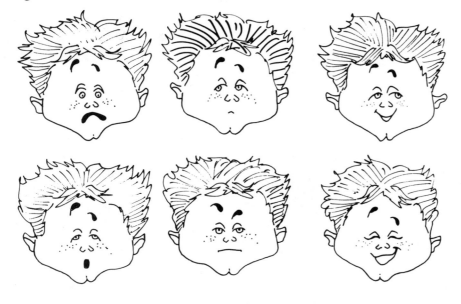

At the other end of the scale, aging deserves a moment. There's more to making a character look old than drawing a beard on him or giving her a faceful of wrinkles. Though the cartoonist is rarely asked to age the same character, an understanding of the aging process as it relates to cartoons is helpful. Knowing how a face changes with time can add verisimilitude to *any*-age face. Let's see this young boy through to old age.

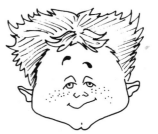

In the first drawing his hair is a little wild and unconventional; his attitude reflects carefree youth. In the second stage his expression has calmed down a bit and his hair is neater; otherwise he's pretty much the same.

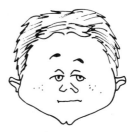

Now his face narrows as he loses his baby fat, and his nose broadens just a bit. He loses that "cute" look as he reaches adolescence. The next picture shows cartoon middle age: hair loss with a little gray in the temples and some bags forming under the eyes.

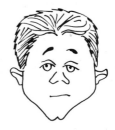

In the last picture we've added glasses and deeper wrinkles and made the hair totally white.

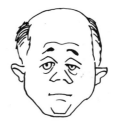

In order to approximate a certain age in a cartoon, you have to break down the way a character stands, moves, and dresses and then combine these mannerisms in a homogeneous figure. All of these factors together are important in conveying an impression of age.

It's time for you to review what we have covered so far and (you're going to grow weary of hearing this) keep drawing. There's no real shortcut to the level of expertise you aspire to; the only recipe for success as a cartoonist is constant application. But look on the bright side: it's not really work.

ANIMALS

Our feathered, furry, or finned friends have been a favorite subject of cartoonists for a long time. Cartooning and animals seem to be made for each other, with a tip of the hat to a thing called anthropomorphism. If all cartoonists had to draw animals as they really are and were unable to imbue them with human traits, it would be over. Can you imagine Bugs Bunny as a timid, nose-twitching rabbit? Of course not—his appeal is his wise-guy arrogance. When you create an animal character, it should be based on a human characteristic, be it asset or flaw. We tend to give animals human character traits anyway: pigs are greedy, foxes are sly, tortoises are slow, owls are wise, and so on. These stereotypes are a good place to start for purposes of humor, but use your imagination—you don't have to stick to these rules.

Here again is a wonderful opportunity to dig into your dictionary for those animal pictures. Search through *National Geographic* or copy pages from books at the library and built up that file. You should have everything in there, from aardvark to zebra. Remember that exaggeration is the key to successful animal cartoons; if your drawing is too realistic it won't be funny. And try to avoid being "cute"—don't make every animal look like Bambi. You have to be able to draw the vermin and the snakes as well as the cuddly, nonthreatening variety.

To draw animals we return to our old standbys the geometric shapes. For instance this owl . . .

And these winning creatures . . .

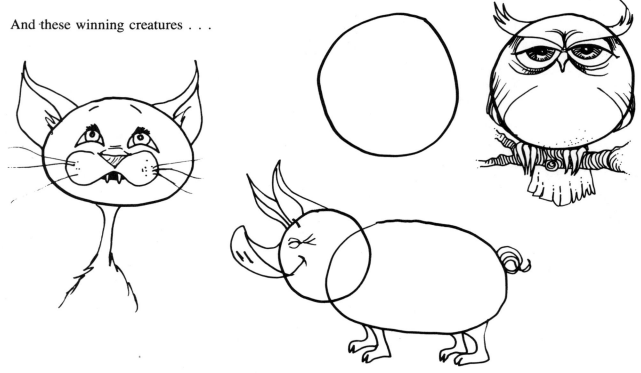

This lion's head was constructed from a rectangle and a circle.

And this monkey from a triangle. (Remember the weightlifter a couple of chapters back?)

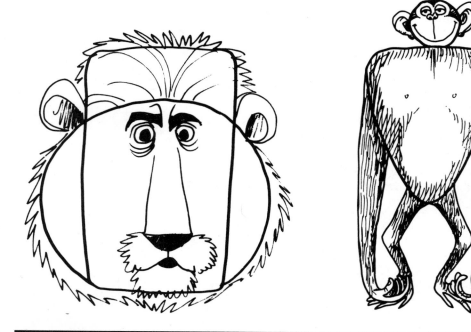

The following animals were created from circles.

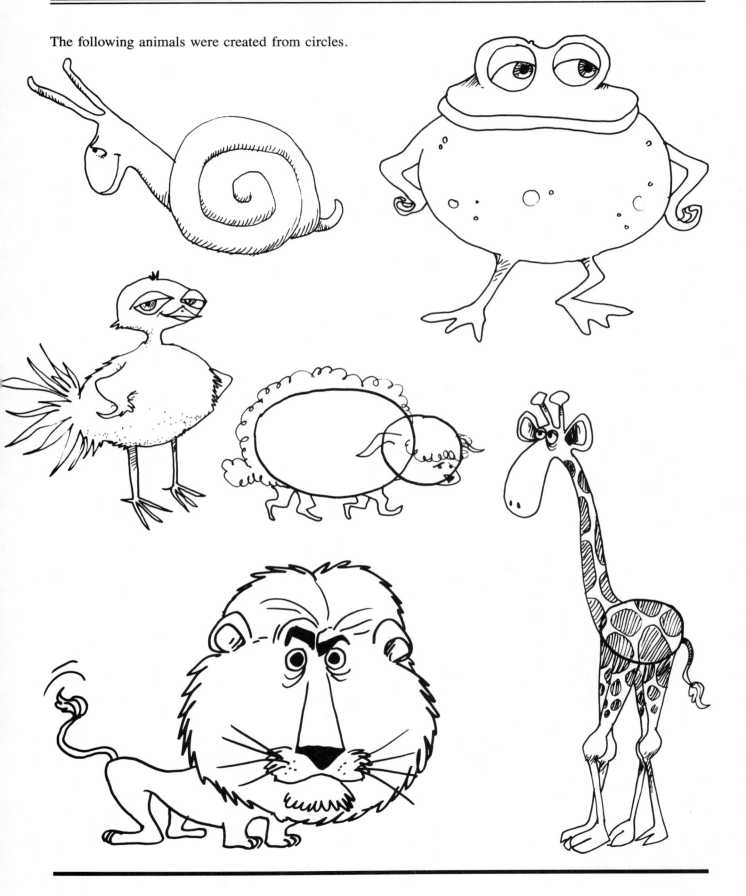

And this bear from two oblong shapes . . . one inside the other.

This graceful horse was fashioned from a triangle.

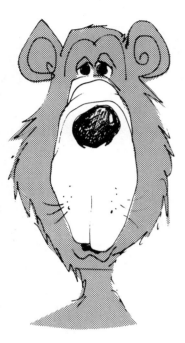

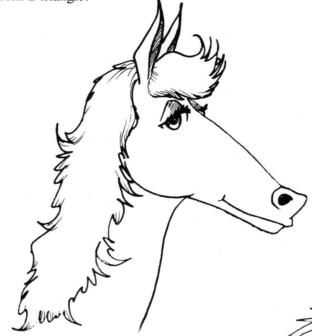

And this cocky little porcupine from an oval.

This thirsty elephant has an extremely simple base as its beginning. Just a big heavy pear shape.

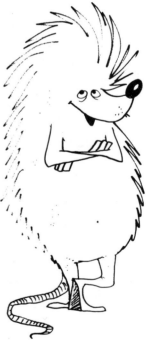

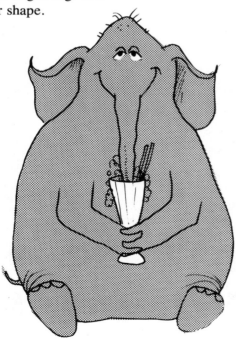

The same rules about drawing children apply to these cuddly cubs: larger heads, smaller bodies.

As opposed to the rules for drawing their mom, who has a larger body and a smaller head.

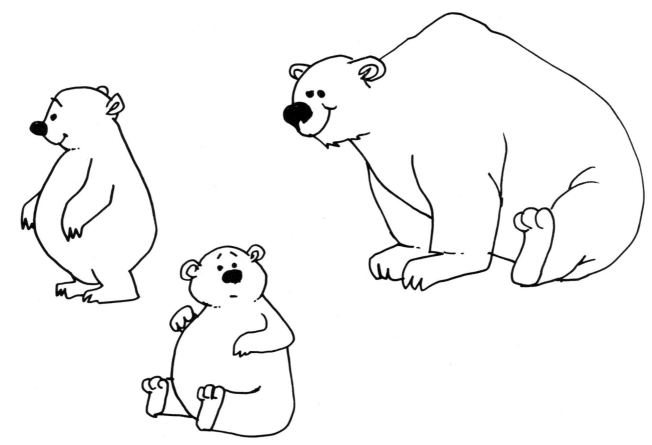

Now watch the metamorphosis of this tiger as we go from a realistic sketch to a lighter version and finally a cartoon.

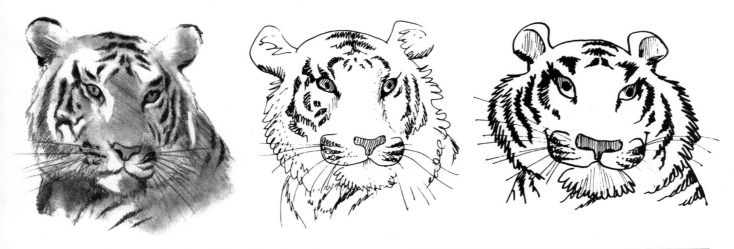

Here's an example of anthropomorphism. I've turned this man into a dog merely by changing his hands and feet into paws, blackening his nose, and reshaping his ears. Everything else remains the same. Sometimes you can start from a human base and turn it into an animal instead of beginning with the animal itself.

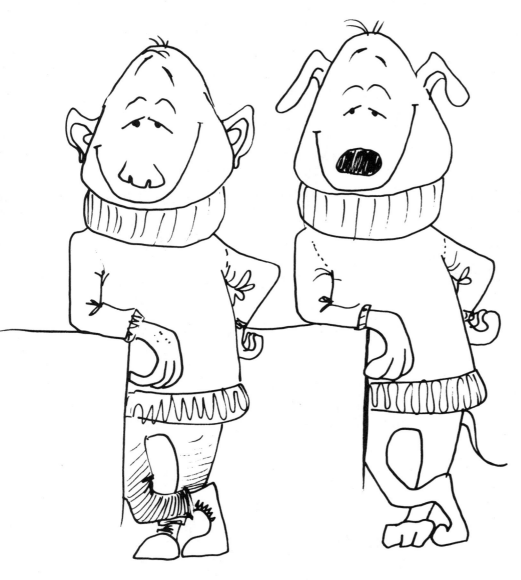

As with humans, cartooning animals is a lot easier when you have good sources of inspiration. Go to the zoo and sketch or take pictures for later reference but try to observe them "live." Their behavior will give you wonderful ideas, their expressions and idiosyncracies are certain to inspire you. If you have a pet, follow it around, sketch it while it's sleeping or playing, when it's cranky or affectionate. Capture all of its moods; you'll be able to apply them to other animals as well. If you observe your dog getting fierce, you can show that same ferocity in your drawings of a lion or wolf or other animal.

This gentleman chimpanzee evolved from a series of sketches I did at the zoo.

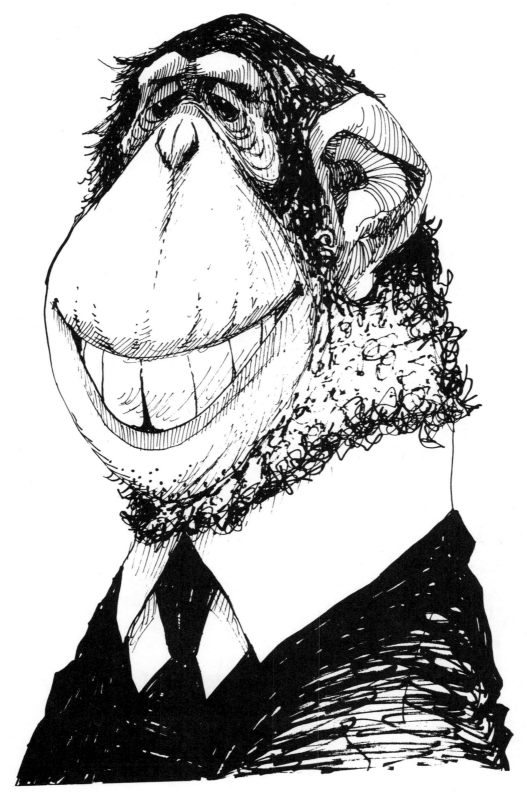

Dogs are the cartoonist's best friend because they come in so many shapes and sizes. Here are only a few. I'm sure you can add many of your own to this group.

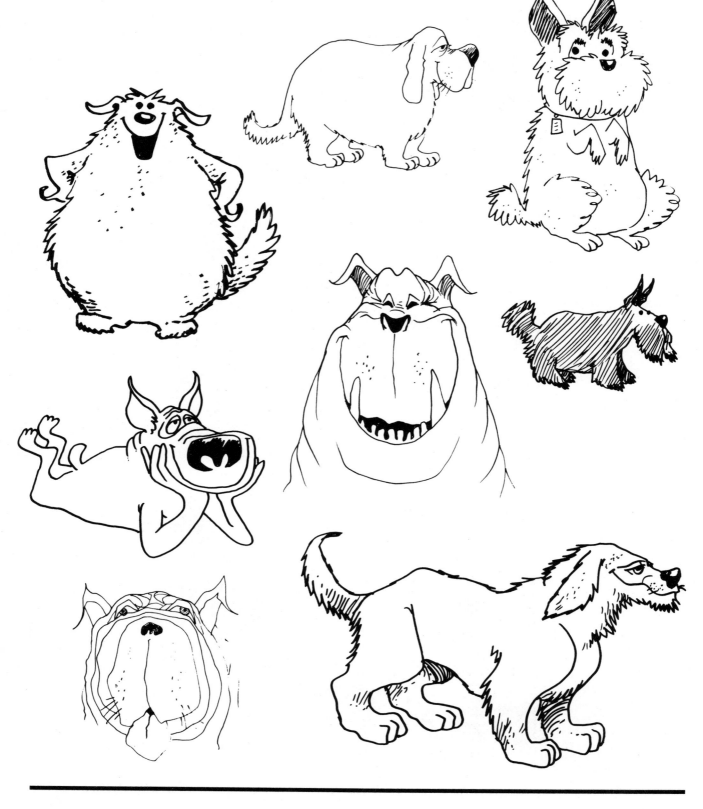

Here are a few of the less appealing members of the animal kingdom. . . .

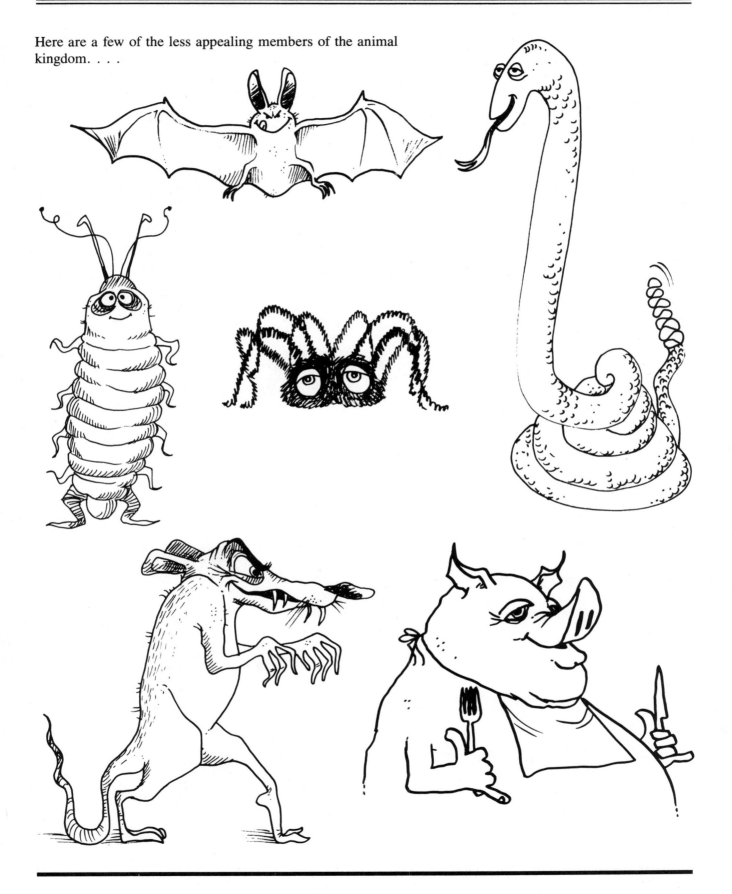

These wonderful fantasy figures who inhabit the worlds of mythology and literature are usually warped versions of human beings or amalgamations of animals and human beings. A centaur is half man, half horse; a unicorn is a horse with an exotic horn; a faun is half goat, half man. I have included here an array of trolls, goblins, ogres, fairies, gnomes, elves, leprechauns, and wizards to help stimulate your imagination in this area. After this you're on your own. Invent a few creatures of your own for practice.

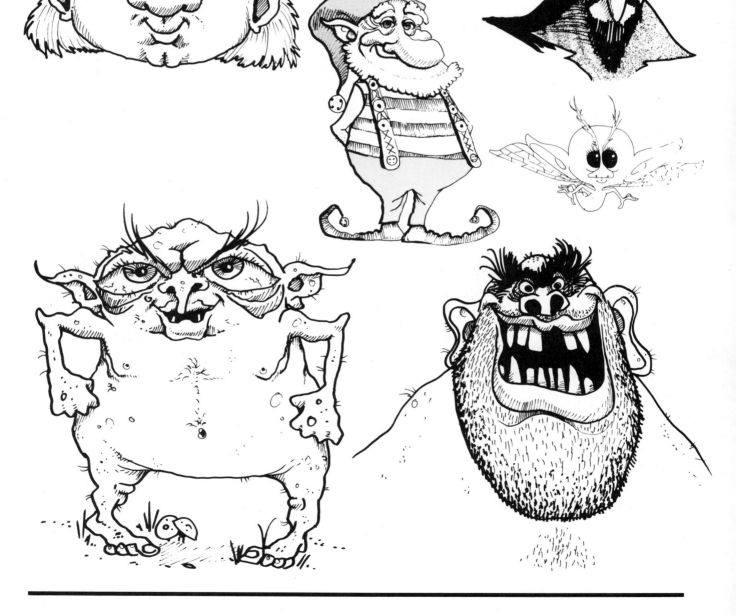

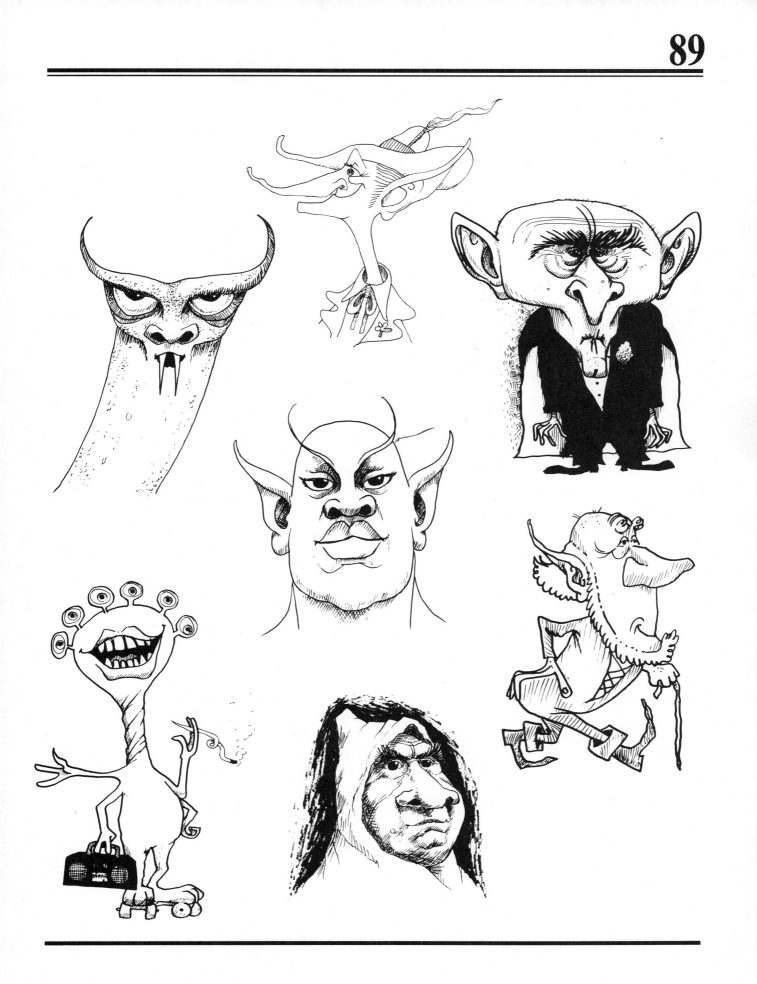

TECHNIQUE

One definition of technique is "the manner in which technical details are treated"; another is "working methods or manner of performance, as in art, science, etc." The one thing I'm sure of is that technique can be as individual as your signature. Technique comes in an infinite variety, and one (or more) is just right for you.

Technique is closely linked to style. Your special approach is determined by your skills and materials. In other words, the more flexible, practiced, and dexterous you are with a pen or brush, the more avenues of style are open to you.

Technique, like anything involving hand-eye coordination, can be learned. It requires practice, of course, but once you understand a few basic principles the handful of cartooning techniques can be learned without too much difficulty. And believe me, it'll be more than worth the investment in time at your drawing board.

First off let's address the question of pen-point width, which has a remarkable effect on a cartoon drawing.

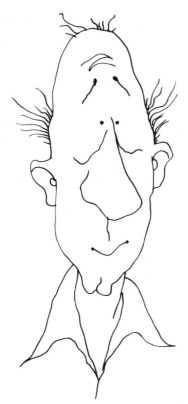

This drawing was done with an extra-fine point.

This one with a medium fine.

And this one is much bolder.

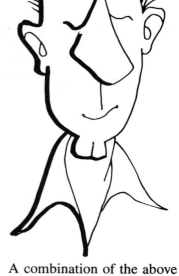

A combination of the above can also prove interesting.

Here I've outlined some delicate vertical hatch lines with a bolder stroke in order to achieve a novel effect.

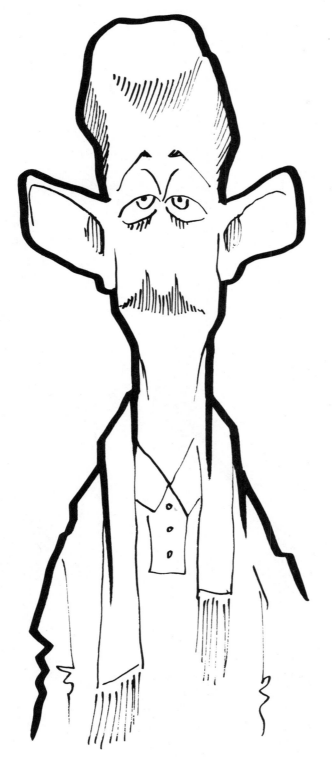

Some cartoonists favor a uniform width of line, while others specialize in different widths, caused by varying pressure on the pen. The new crop of cartoonists is gravitating toward the "untutored line," which gives work a spontaneous, loose quality that is currently in vogue. I know cartoonists who will pass over slick, controlled sketches in favor of submitting the "messiest" of the lot.

This military man has been drawn with a fairly controlled hand.

And then with a looser, less tutored line.

And finally with an extremely casual, bold approach.

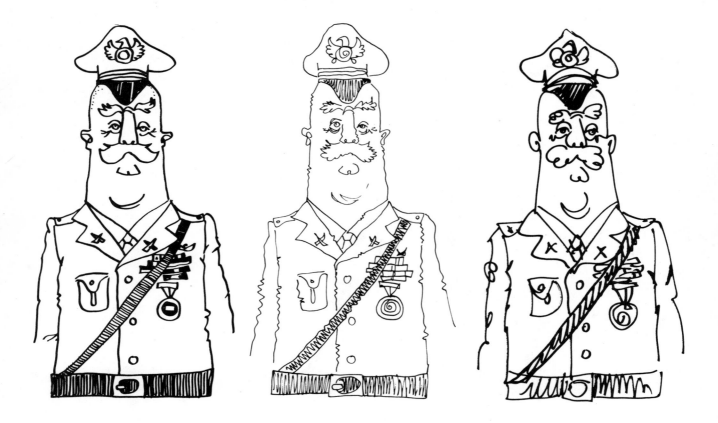

I often find that the subject matter dictates the particular style to me. For instance, would you draw a delicate little girl in strong brushstrokes? Not as a rule. You might want to use a soft lead pencil, which would allow you the luxury of subtle shading, or a wispy, fine pen to capture the fineness of her features. The choice is entirely up to you, depending on your subject. You might find something arresting and fresh by doing exactly what I don't recommend.

I like the challenge of drawing in a variety of styles and media; sometimes the precision of an ink drawing, complete with carefully defined lines and decorative swirls and curlicues, seems perfect—and then again just as perfect a sketch might appear that has only taken seconds to complete.

There are a few basic effects you should learn to master, as they are useful for shading, for backgrounds, for creating a sense of depth and texture.

The shading for this bizarre creature was done by hatching with a series of parallel (usually diagonal) lines.

Here are a few examples of hatching and crosshatching. (Crosshatching is just that—hatching in opposite directions.)

And for a more serious approach . . .

And into a more regimented hatching technique that lends a designed aspect to the drawing.

Hatching has many variations. The lines can be evenly spaced, or they can start out very close together and then widen as you wish more white to show. I recommend putting in a lot of time on this stroke. It's basic to all cartooning and will prove an invaluable addition to your bag of tricks.

This is an example of stippling—which is nothing more than the cartoonist's version of pointillism, a pattern of dots.

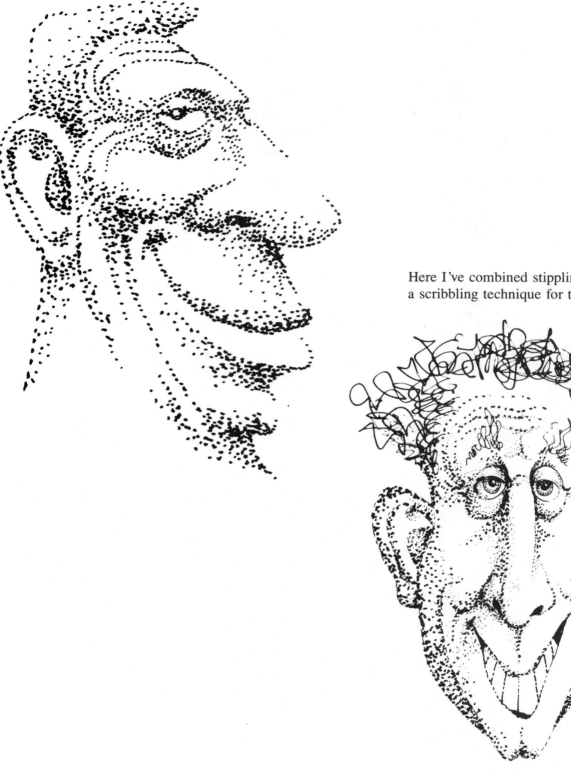

Here I've combined stippling with a scribbling technique for the hair.

This drawing of an old prospector was executed with a ballpoint pen in an extremely casual style. As you can see, my pen rarely left the paper when I was doing his beard.

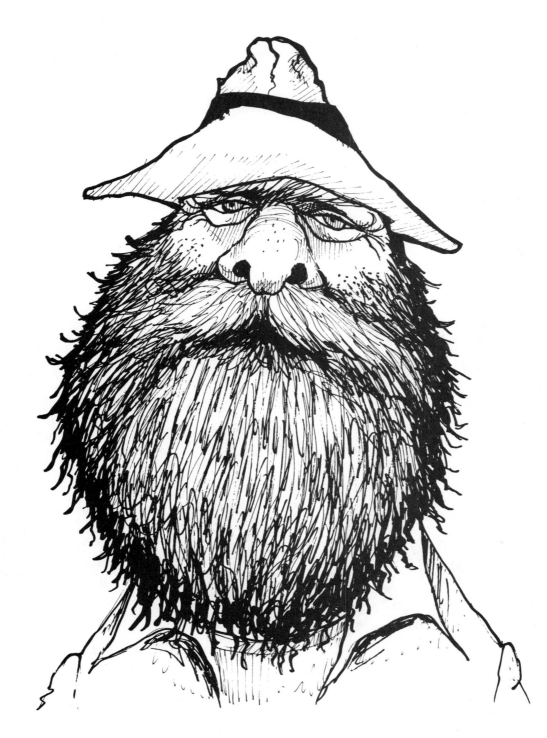

Here's a different technique: a series of dots and flourishes makes for an unusual approach on this cartoon face.

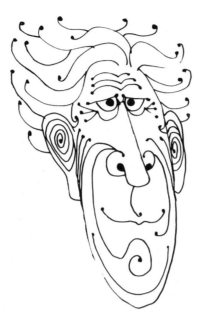

I've done this next fellow a number of ways to demonstrate a variety of techniques. First, a rather casual ink sketch.

Now a more rigid approach with a ''parquet pattern'' shadow.

As I simplify him further and fill in masses of black, he moves from cartoon into the area of design.

And the same character takes on an entirely different look when drawn with a brush in a loose, scribbly style.

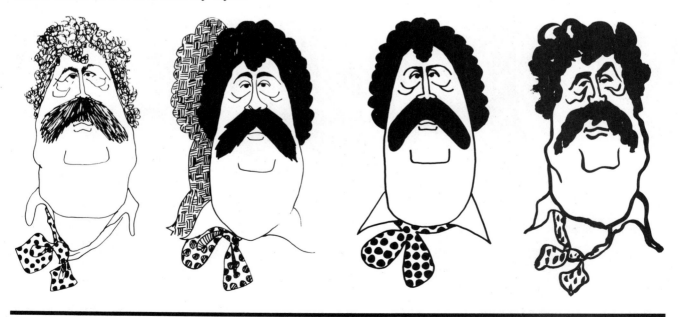

Textures are essential to the cartoonist; you should be able to convey the sleekness of silk or the scratchy roughness of tweed. Surprisingly enough, these techniques are not difficult to master.

Take the following figure for instance. I've dressed him in various outfits. In the first sketch the silk texture of his hat was achieved by "feathering out" the hatching to produce a glistening look. The little hairs and dots that characterize his tweed jacket will be used later as stubbly beard. His herringbone tweed pants speak for themselves. Not the most tasteful of outfits, but ideal for our purposes.

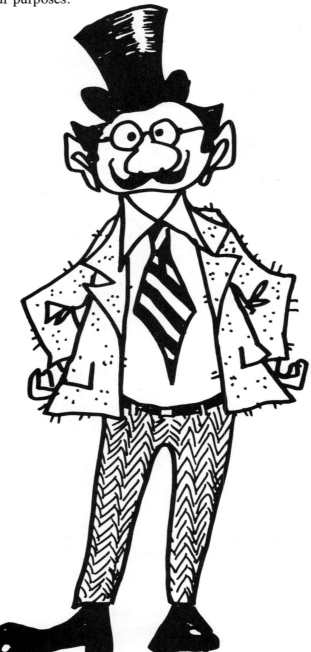

Here I've hatched his jacket and crosshatched his trousers.

Now he's in a sweater (indicated by stippling), and for his pants I used a small sable brush. And there, as promised, is the ''tweedy'' chin stubble.

Here's yet another treatment for the pants. This time I've done a variation on the parquet effect by moving the pattern in different directions and then using a loosely stippled stroke as the parquet pattern thins out.

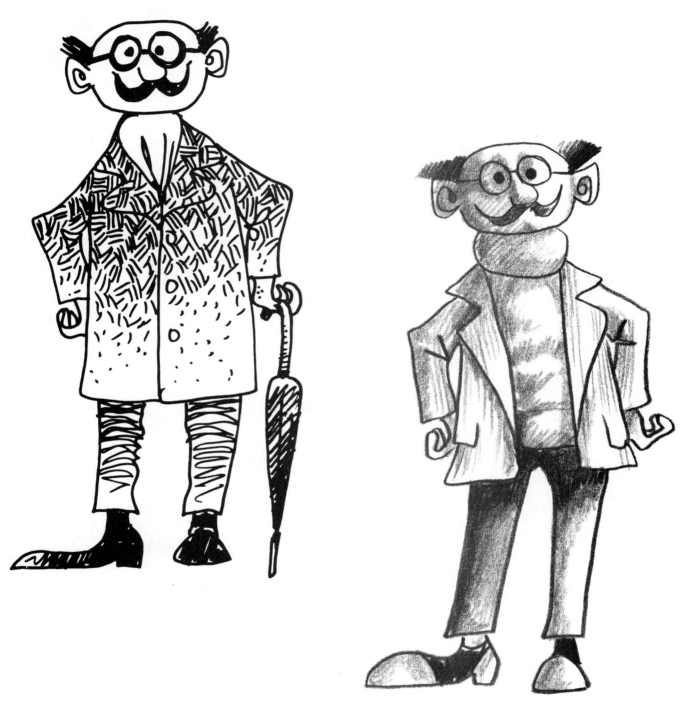

Here's the same gentleman done with soft lead pencil; with pencil we can achieve more graduated tonalities. Notice the wide-wale-corduroy effect on his jacket.

The brush gives you much more freedom in a drawing than the pen. Take a brush and practice with it until you achieve that fine blend of control and relaxation that makes brushwork so appealing. I did this woman with a small sable brush.

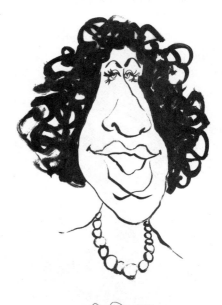

Here she is in pen with a wash added. Wash is merely ink diluted in water for a less opaque tonality and is useful for subtle shadings.

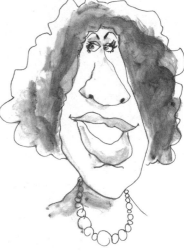

This time, after I sketched her with pen, I dipped my thumb in ink and "smudged in" the hair and lips. Messy but effective (the other fingers work as well as thumbs).

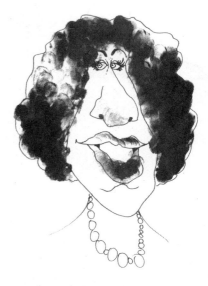

The symmetry of this woman, combined with the solid blacks and her hatched hair, makes an intriguing character.

This unusual effect was achieved by lightly washing down the area of the hair and then adding drops of India ink with a small brush while the surface was still fairly wet.

Here's a girl drawn in a style I call (for lack of a better name) spaghetti-hair.

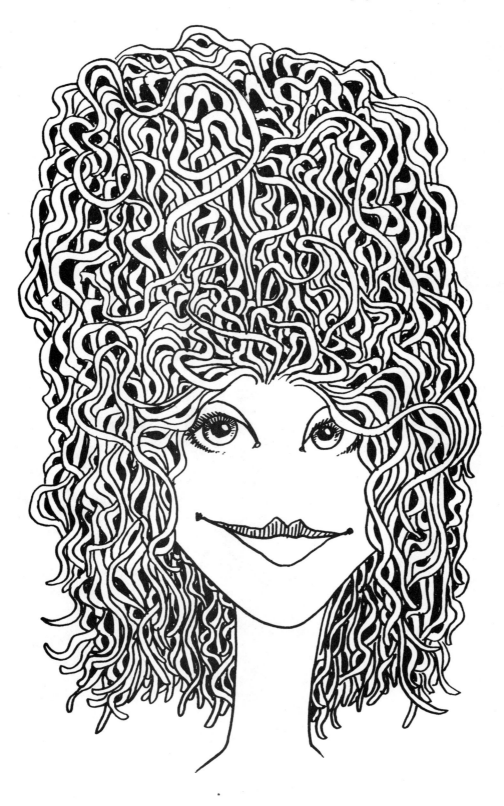

This gnome was done in a technique I've used for years. I do a sketch with a felt-tip pen and then wet the end of my finger and smudge areas of the drawing as I go along. This works especially well with colored pens.

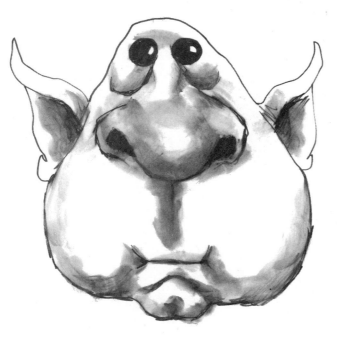

Here's the same character drawn with my favorite sketching pencil, Beral Draughting No. 314, followed by a lot of fingertip rubbing . . . after which I bring out the highlights with a good eraser.

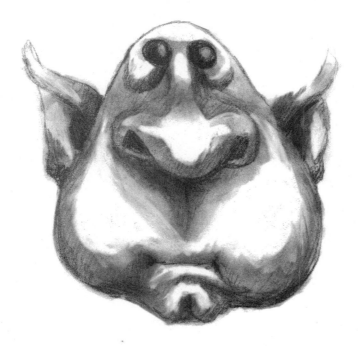

In this drawing I used the side of a grease pencil on a sheet of drawing paper with a coarse ''tooth'' (the grain in textured paper).

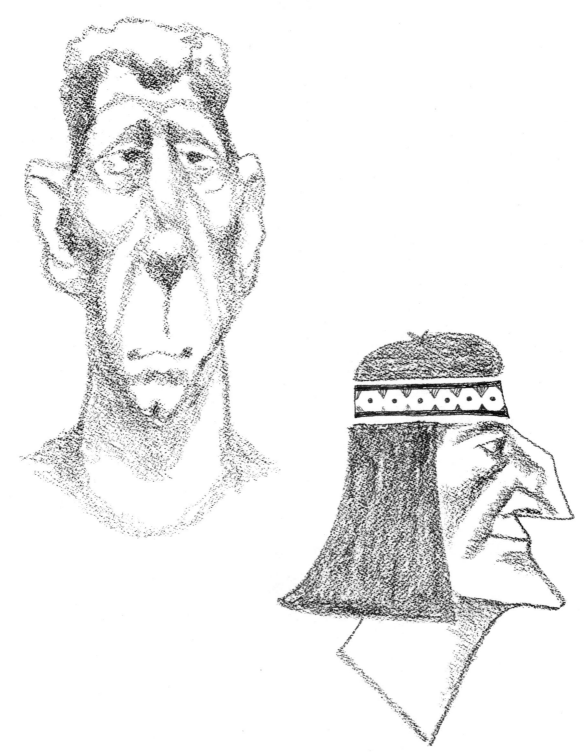

And I combined ink (in the headband) with pencil for this design effect.

I did this bizarre character in pencil because it allowed me to indulge in some shading techniques, especially in his Reaganesque neck folds.

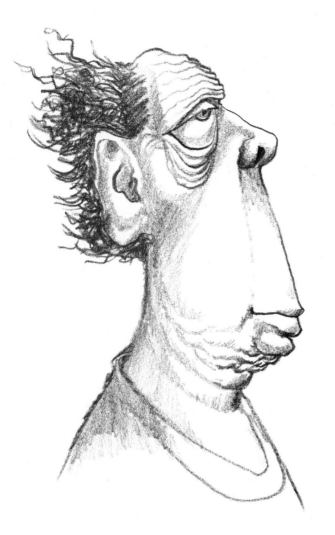

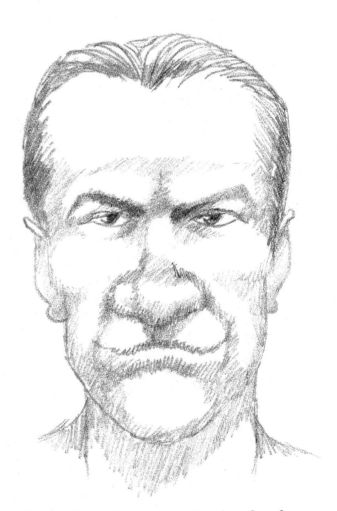

This man was done with a hard pencil on a nontextured surface for a smoother look.

Here I used a white pencil on black, rough textured paper. You can see how a simple cartoon seems to take on another dimension when you vary the techniques.

This was done originally with colored pencils (reproduced here, of course, in black and white) but notice how the grain (the tooth) of the paper aids in shading.

A technique I'm particularly fond of involves scratchboard, a black-surfaced cardboard with a thin ($\frac{1}{32}$-inch) layer of white clay beneath. You can buy scratchboard already blackened, or you can wash the entire surface of the board with India ink. You scratch into the black surface, allowing the white to emerge. You think backward, in a sense—a positive-negative transference. Instead of drawing in the blacks, you're bringing out the white, dealing only with the highlights. It's very valuable for commercial artwork.

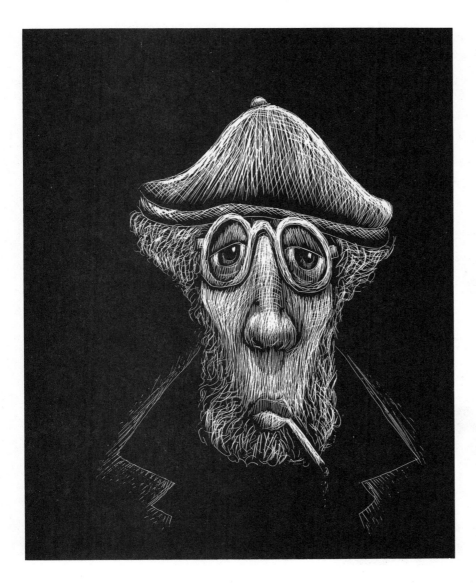

We should spend some time on mechanical tints, or pressure graphics (they're known by different names), those sheets of tiny, evenly spaced dots and other designs that are used so extensively in commercial art, especially in comic strips, single-panel cartoons, and so on. I've used them now and then throughout the illustrations in this book. These sheets of mechanically produced shadings are very useful for laying in gray tones; artists often use them instead of relying on their own pen strokes or a wash. These sheets come in a wide range of designs; I've included a few samples here to show you how they are used.

The dotted mechanical tint on this hobo's coat and hat produces a consistent solid gray mass and dresses up the drawing.

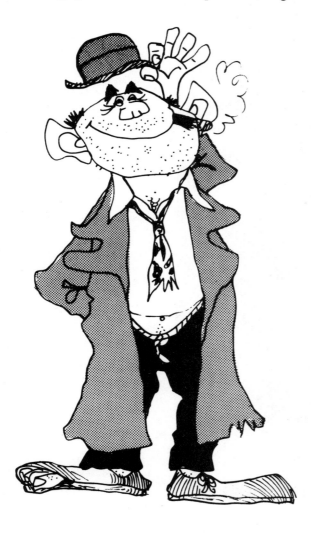

I chose a darker tint for this man's hair and eyes.

I covered this guy's jacket and slacks with one tint and then placed another layer over the pants for a different effect. The more layers you use, the more the pattern changes. Experiment with these sheets—it's fun.

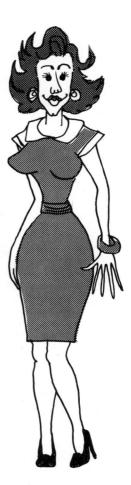

This woman's dress is done in a diagonal tint, her hair in a denser dot pattern.

Here's a small checkered tint.

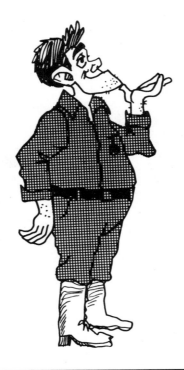

This drawing combines a tint and pen work. First I drew the character and his plaid coat, then I laid the crosshatch tint on his jacket and tie. I did two layers of another tint on his trousers for a deeper effect.

You can see how the herringbone pattern enhances the sharpness and angularity of this geometric drawing.

But be forewarned: these sheets cost about four dollars apiece, so use them sparingly.

Here's a technique that requires a minimal investment—a discarded toothbrush and some ink. Merely mask off the entire area around a carefully cut-out design (in this instance the hair), then dip your toothbrush in ink and run your thumb across the brush so that it sprays the ink out with a spattered effect. It's an effective technique, somewhat like a cheap, crude airbrush.

Most lettering patterns of various sizes and descriptions, and a wide variety of designs in the public domain are available at any good art store. The designs are called clip art, because you cut them out and paste them up. Take a look: you'll be amazed at what you can get out there. Most lettering and mechanical tints are pressure-sensitive; you merely burnish them into place, cut carefully around the outline with an X-acto knife, or scalpel and peel off the unwanted sections.

I don't have room to describe the entire range of techniques that are applicable to cartooning. Experiment with as many tools and papers you can to find what you're most comfortable using.

MATERIALS

Before we get into a discussion on specific materials, your most important decision involves where you're going to work. You may not have the luxury of a studio or an office in which to work, but whether you're in the kitchen, the dining room, or the basement, the space should be well lit (naturally or artificially), with a comfortable chair and plenty of wastebaskets all around for rejected drawings. You'll need them. (I figure my disposal ratio is eight to one.)

Second only to a wastebasket in importance are your brushes. The best brushes, I think, are sable. I use the 00, the 2, and the 4 but I keep a big one like a number 6 around for filling in large areas quickly. A very important note: always keep a jar of clean water nearby and rinse out your brushes immediately after using them. It will help prolong their lives and their precious points. When you're done for the day it's a good idea to wash all your brushes in soap and water. Brushes are fairly expensive, but they'll be with you a long time if you treat them well. Also, it wouldn't hurt to invest in a few square-tipped synthetic brushes for filling in and doing dry brush work.

Pencils range from the 8H, very hard, all the way to 8B, which is very soft. I enjoy working with a soft lead because I like to smudge with my fingers. As I said before, Beral Draughting No. 314 has long been one of my favorites. But if you're doing a light sketch, a hard pencil is preferable. You should also invest in a few non-photo blue pencils, which come in a shade of blue that does not photograph or show up on Xerox copies. It's a great advantage to be able to sketch out an entire drawing, ink it in, and then send it off without having to erase all those nasty little pencil marks. I did most of the sketching for the work in this book with a non-photo pencil.

A grease pencil should also be included in your supplies. When you work with it on a rough surface you can scumble it nicely so that subtle gradations of tone are possible.

Of course there are many other types of pencils—charcoal, colored, carbon . . . Go to your local art store and see the incredible range of drawing instruments. What I recommend here are the ones that cartoonists use most frequently.

Pens are a more complex matter. They come in a multitude of shapes, sizes, and types. There are cartridge pens like the Rapidograph, which holds a reservoir of ink so you don't have to return constantly to the inkwell; then there are "dip pen" series like those of Speedball, Gillott's, and Hunt. Each pen tip has a unique character and width. You should sample the wide variety available to you and choose the ones you feel comfortable with.

Try Gillott's 170, 290, and 1290; Hunt crow-quill pen numbers 102, 512, and 99; and Speedball B-5, B-0, and C-2. That's a pretty good cross-section for starters. Or you might try the Esterbrook #788 or the Pelikan #120 fountain pen.

I also enjoy using a line of pens called Penstix. They're like felt-tips except that they contain India ink. They come in three widths: fine (which is really a medium), extra fine, and extra extra fine; and they're convenient and reliable. I did much of the final work in this book with these pens.

The drawing inks used by cartoonists are usually waterproof (it's a good safeguard against water spills around the house and accidents that might happen in the mail or editor's office). Also, waterproof inks mix well with water and other media. It's a good idea to put your bottle of ink in a rubber holder or some other device that prevents it from tipping over. And pick up a few china or enameled mixing cups for diluting your ink into a wash. If you want your ink to dry slower, use a little distilled water—a few drops will do.

We all make mistakes, so thank heavens for bleedproof whites. These opaque watercolors can cover up a host of drips, drops, smudges, and slops. If you apply a bleedproof white lightly enough you can actually ink over it, and when the finished drawing is reproduced you'd never know a mistake had been made. I buy this stuff by the case.

Here's a good idea for an inexpensive lightboard. Take a Lucite or plastic frame, remove the cardboard section, and lay it open side down on your drawing table. Then invert an adjustable table lamp and slide it under and into the frame. Now you have a smooth, well-lit surface to trace on.

As far as types of paper and their surfaces go, this also is a personal choice and depends on the medium you are working in and the effect you want to achieve. Obviously, smoother surfaces are designed for inks while coarser surfaces, those with a "tooth," are better suited for pencil, pastel, charcoal, and grease pencil.

There are many other supplies you'll want to gather as time goes by, but to begin with I recommend the following:

> A drawing board, 20″ × 26″
> A pair of scissors
> Scotch tape
> Double-stick tape
> A 16″ brass-edged ruler
> A transparent 12″ triangle
> Mucilage
> Tracing paper
> An assortment of erasers:
> kneaded rubber, art gum, or Pink Pearl (Eberhard Faber)
> Pencil sharpener, electric or otherwise
> Compass with lengthening bar and divider
> Fixative
> Utility knife or X-acto knife

You're probably not going to buy all of these supplies at once—nor should you—but as you grow more sophisticated in your work, little by little you will amass all of this and more.

RAP-UP

So now do you look at cartooning with different eyes? I hope that through this book you've gained respect for this quirky, elusive art. The quickest way to change your perception of something is to attempt it yourself. In fact it wouldn't be a bad idea if some of cartooning's severest critics were to give it a try sometime: I have no doubt that their opinions would be quickly and drastically altered.

Cartooning is, admittedly, a most peculiar form of art. It has no real guidelines and it is constantly changing; it intrudes upon other art forms—much to the chagrin of the ''serious'' artists (or should I say those who take themselves seriously). But its impact can be felt in the artistic community more and more every day. Picasso's works were filled with humor, and some of his later etchings and lithographs could be considered sublime cartoons. And artists like David Hockney and Michael Ffolkes steadily make their way into the museums of the world. The whimsical works of Boulanger and the witty pen of Saul Steinberg have also aided in this long-overdue acceptance.

It will be very exciting and interesting to watch as the art of cartooning undergoes many changes in the next few decades. And it's not too late: you can be a part of that change. Cartooning has an enormous advantage over other artistic endeavors. You can learn the basics quickly. It's like racquetball as opposed to tennis: you can walk into a racquetball court and instantly be a mediocre player, while in tennis it takes five years to reach the same level. If you start now and apply yourself, even for a half-hour every day, you'll be amazed at what progress you will have made at the end of a week's time. It requires focus and application but the saving grace is that it's fun.

The personal style you develop is a result of your life, your personal observations, your attitudes. No one has experienced that but you, and that's what will inform your drawing and make it unique. Not talent

always, not intelligence—merely your own personal perspective. Try not to sell that precious individuality short by consciously imitating another artist's style, no matter how impressed you are by his or her work. We're all influenced by other artists, of course. It can't be helped; we are all subliminal pirates to a degree. But be patient and allow your own style to emerge. Who knows, it might even prove to be better than that of the artist you chose to emulate.

I sincerely hope that through the course of this book I have been able to interest you, encourage you, intrigue and instruct you in this crazy art. You could be one of those artists who will help shape the next decade. Does that sound impossible? It's not. Garry Trudeau has certainly swayed public opinion with his wonderful strip *Doonesbury,* and no one can deny the impact made on generations of Americans by Charlie Brown and the rest of the *Peanuts* gang. Cartooning has had an enormous influence on all of us, and not only through the comic narratives; editorial cartoons are potent forces in the political world. A pointed, telling panel can sometimes broadcast a message or break a story better than a newscaster. And look at the pleasure Gary Larson's twisted vision gives millions of readers.

Cartooning is definitely a career worth working for.

If you apply yourself, if you strive to reach that next plateau, if you focus your energies on the task at hand, without the need for instant praise or remuneration, you can become a cartoon artist. If you do, I hope that I, in some small measure, will have had a hand in it. Nothing would please me more.

ABOUT THE AUTHOR

Dick Gautier spent his early years in his native Los Angeles as a standup comedian and singer, and, in between jobs, as a painter and cartoonist. He eventually migrated to New York, where he created the role of Conrad Birdie in the smash Broadway musical *Bye Bye Birdie*. He subsequently returned to the West Coast to star in several motion pictures and TV series, and guested on hundreds of TV dramatic, comedy, and talk shows. He created the role of Hymie the robot on *Get Smart*.

Dick has three children by his first marriage and lives in Toluca Lake, California, with his present wife, actress Barbara Stuart. He is an active screenwriter and director, and his hobbies include painting, etymology, and tennis. His first book, *The Art of Caricature,* was published in 1985.

Learn the arts of caricature and cartooning,
for hours of fun and entertainment!

With these profusely illustrated, easy-to-follow guides from Perigee, you can draw hilarious images in a few strokes.

THE ART OF CARICATURE by Dick Gautier
Foreword by Joan Rivers

Here is an engrossing, enlightening, entertaining guide to the courageous, often controversial art of caricature. Comedian Dick Gautier follows the art of caricature from its origins in antiquity to the present, sharing along the way anecdotes and quotations from some of the world's foremost caricaturists, "those valiant souls… who draw funny pictures for a living." Step-by-step instructions and over 150 illustrations help you zero in on the outstanding features and characteristics that reveal the essence of any personality.

THE CREATIVE CARTOONIST A Step-by-Step Guide for the Aspiring Amateur
by Dick Gautier

Can you flip through a magazine without stopping to read the cartoons? Are you a compulsive doodler with a quirky sense of humor? If your answer to these questions is yes, cartooning may be the hobby or profession for you. With over 500 illustrations and clear, easy-to-follow instructions, Dick Gautier shows you how to become "a master of brevity, someone who can, in a few deft strokes, create an image that will cause laughter, discomfort, or even pain." Here are all the fundamentals you need to start cartooning, from tips on materials and techniques to a host of crazy characters to copy.

CARTOONING THE HEAD & FIGURE by Jack Hamm

Step-by-step instructions and over 3,000 illustrations simplify and teach tried and creating laugh-out-loud cartoons. Hundreds of noses, eyes, mouths, head shapes, expressions and facial conditions, personality types, walking and running figures, manners of dressing, and more illustrate multiple ways and means, styles and techniques of drawing cartoon figures. Whether you're a novice or an experienced cartoonist seeking to hone your skills, you'll find everything you need to know in Jack Hamm's book.

Ordering is easy and convenient. Just call **1-800-631-8571** or send your order to:

The Putnam Publishing Group
390 Murray Hill Parkway, Dept. B • East Rutherford, NJ 07073

Also available at your local bookstore or wherever paperbacks are sold.

		PRICE	
		U.S.	CANADA
___ **The Art of Caricature**	399-51132	$10.95	$15.50
___ **The Creative Cartoonist**	399-51434	10.95	14.50
___ **Cartooning the Head & Figure**	399-50803	6.95	9.25

Subtotal $_____

Postage & handling* $_____

Sales Tax $_____
(CA, NJ, NY, PA)

Total Amount Due $_____
Payable in U.S. Funds
(No cash orders accepted)

*Postage & handling: $1.00 for
1 book, 25¢ for each additional
book up to a maximum of $3.50

Please send me the titles I've checked above.
Enclosed is my ☐ check ☐ money order
Please charge my ☐ Visa ☐ MasterCard
Card # _____ Expiration date _____
Signature as on charge card _____
Name_____
Address _____
City _____ State _____ Zip_____

Please allow six weeks for delivery. Prices subject to change without notice.